FUTURISM

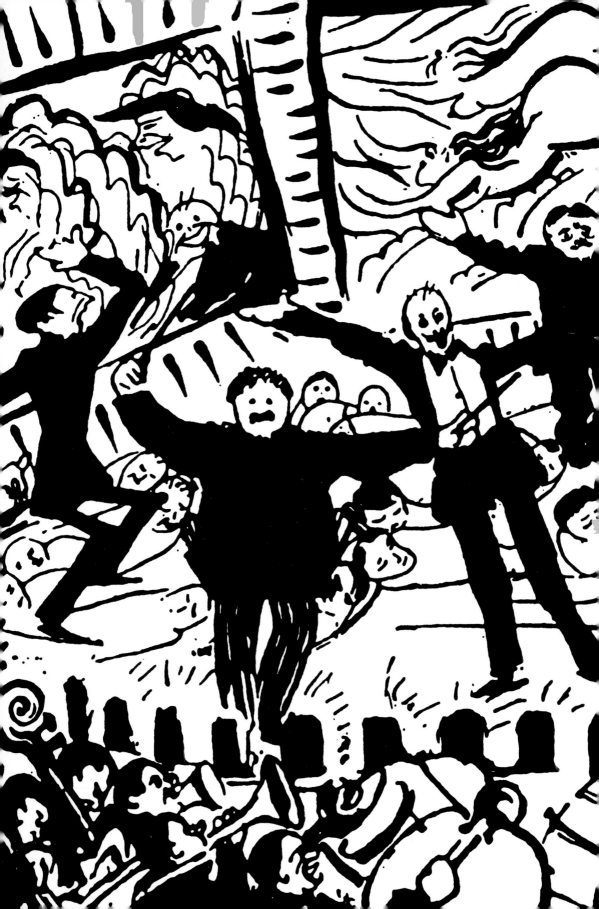

FUTURISM

RICHARD HUMPHREYS

CAMBRIDGE
UNIVERSITY PRESS

PUBLISHED BY THE PRESS SYNDICATE OF THE
UNIVERSITY OF CAMBRIDGE
The Pitt Building, Trumpington Street, Cambridge
United Kingdom

CAMBRIDGE UNIVERSITY PRESS
The Edinburgh Building, Cambridge CB2 2RU, United Kingdom
http://www.cup.cam.ac.uk
40 West 20th Street, New York, NY 10011-4211, USA
http://www.cup.org
10 Stamford Road, Oakleigh, Melbourne, 3166, Australia

First published by Tate Gallery Publishing Ltd, London 1999

Cover designed by Slatter-Anderson, London
Book designed by Isambard Thomas
Typeset in Monotype Centaur and
Adobe Franklin Gothic

Printed in Hong Kong by South Sea International Press Ltd

Library of Congress Cataloguing-in-Publication Data is available.

A catalogue record for this book is available from the British Library

Measurements are given in centimetres, height before width,
followed by inches in brackets

Cover:
Giacomo Balla
Abstract Speed: The Car Has Passed 1913 (detail of fig.29)

Frontispiece:
Umberto Boccioni
A Futurist Evening in Milan 1911 (detail of fig.23)

ISBN 0 521 64611 1

Contents

I

CRASH:
TIME, SEX MACHINES AND THE FOUNDING MANIFESTO

In sul passo dell'Arno	In the crossing of the Arno
I tedeschi hanno lasciato	The Germans have left
Il ricordo della loro civiltà	A souvenir of their good manners

These words were chalked by an Italian on the base of a statue of Dante in the colonnade of the Uffizi, Florence, in August 1944. Referring to the widespread destruction of Italian art and architecture as the Germans retreated in the face of the allied advance northwards, they comment on the finale to an era in Italian history of which Futurism was a noisy and enthusiastic harbinger. Although much was saved from what Churchill called the 'red-hot rake' of the battle line, the disastrous consequences of Italy's alliance with Germany and the end of Benito Mussolini's Fascist regime, were indisputable and irrevocable. The anonymous graffiti forms an ironic epitaph to the visionary bravado and rhetoric of the poet Filippo Tommaso Marinetti (1876–1944) in his 'Founding Manifesto of Futurism' published on the front page of the leading Parisian conservative newspaper *Le Figaro* thirty-five years earlier (fig.1): 'So let them come, the gay incendiaries with charred fingers! Here they are! Here they are! . . . Come on! Set fire to the library shelves! Turn aside the canals to flood the museums! . . . Oh, the joy of seeing the glorious old canvases bobbing adrift on those waters, discoloured and shredded! . . . Take up your pickaxes, your axes and hammers and wreck, wreck the venerable cities, pitilessly!'

'Futurism' is a term that may suggest a number of things. For example, when

we describe something as being 'futuristic', we mean to convey an idea of scientific and technological advance beyond that which presently exists. The images and themes of classic science fiction are usually 'futuristic', featuring vast, gleaming, streamlined spacecraft travelling faster than the speed of light to planets billions of miles away. The future is a place in which aliens with unimaginably enormous brains live in cities of mile-high skyscrapers and

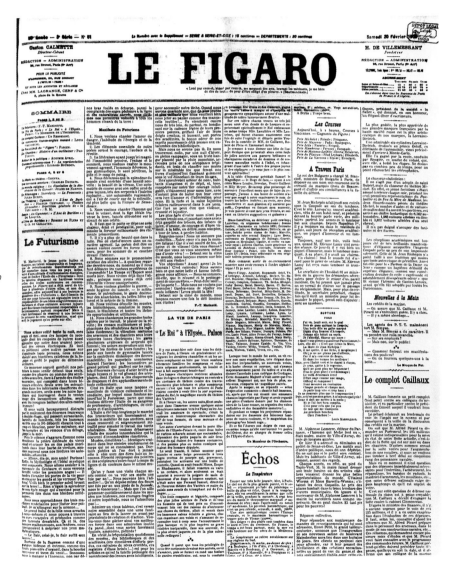

1

Front page of *Le Figaro* 20 February 1909, with the Futurist manifesto

where personal travel is undertaken by molecular decomposition and reconstitution in booths conveniently placed like ubiquitous bus stops wherever one may wish to go. This notion of the 'futuristic' carries with it not only extraordinary technological development but also a complementary vision of the mind and body transformed, giving human beings new mental and physical powers. In this world we will all be supermen and superwomen, or

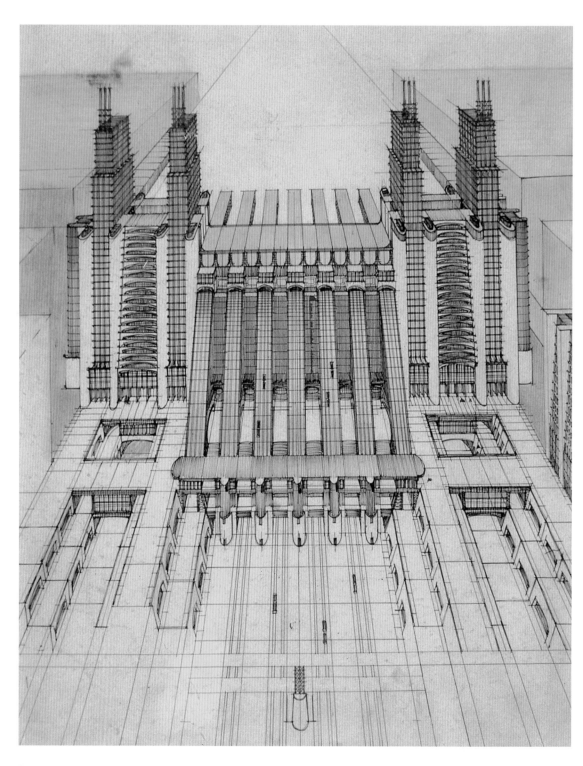

perhaps just genderless super-beings. Thus 'futuristic' tends to imply the infinite possibilities of progress for which there are always signs in the present – the futuristic car designs, presented to us today in increasingly sophisticated adverts, conjure up this world that is yet to come. Strangely, it is also a world that may have had its day, suggesting a heroic and naive aspiration typical of the culture of early and mid twentieth-century Europe and America, rather than our darker, less optimistic sense of what lies in store and our forebodings about, for instance, what the writer J.G. Ballard has called 'a nightmare marriage between sex and technology'.

Obviously, 'futurism' also suggests simply an idea of a segment of time, deriving from the structuring of our experience and language around a tri-partite scheme of past, present and future. Nineteenth- and twentieth-century philosophers, writers and artists, from the Pre-Raphaelites and Marcel Proust, through Henri Bergson and Umberto Boccioni, to Jean-Paul Sartre and Francis Bacon have been greatly preoccupied with time.

Although modern history cannot claim any monopoly on a concern with the temporal, it is probably true that, in a secular culture where it is thought that God may not be available to underwrite our existence and therefore provide a neat conclusion to human affairs, time has been at a premium for the intellectual classes as they have searched its mysterious store of past and present for clues about the future. Prophecy is one of the skills we often expect from our thinkers and creators and it was certainly something Marinetti and the Futurists believed they possessed in impressive quantities.

The English word 'future', loaded as it is, has its etymological root in the Latin *futurus*, which is the future participle of *esse* (to be). Its origin as a verb therefore places emphasis on the idea of 'that which is to be hereafter'. Although in the science fiction sense of the future as a place there is unavoidably a reference to the verb, it does not carry such a strong sense of the existential meaning of the word and thus of its rootedness in the experience of the 'present in motion'.

These are abstract questions but it is helpful to emphasise the complexity of the terms 'future' and 'futurism' and to clarify the distinction between the idea of the future as a noun and, more or less, a place, on the one hand and, on the other, as a verb and deriving its force from present experience. The Italian Futurists were concerned with these distinct but related meanings and in ways that may at first seem a little surprising. For all their manifesto rhetoric about the city, aeroplanes, telephones and all the other trappings of 'modern life', they rarely painted or described the future itself, in the way, for example, that H.G. Wells did. This is not to say that their art is never about such things, nor that they were unenthusiastic about how technological life might turn out – after all, the great Futurist architect Antonio Sant'Elia drew distinctly futuristic and fantastic cities (fig.2) – but a close look at their art and writing suggests that 'futurism' also meant something else to them. Indeed, their critics frequently pointed out that horses, dogs and scenes of ordinary street life were more prevalent in their paintings than the high-tech images that their pronouncements might lead one to expect. What their leader Marinetti and many of his associates meant by 'Futurism' was as much a rejection of the past

2
Antonio Sant'Elia

Airport and Railway Station with Elevators and Funiculars over Three-levelled Street
1914

Ink and pencil on paper
50 x 39 (19¾ × 15¼)
Musei Civici, Como

as an idolatrous concern with the portents of the future. For them, Futurism was a highly politicised philosophy of life rooted in their rejection of a host of forces, which they believed were inimical to the growth and modernisation of Italy. The insistence on the destruction of Italy's heritage is part of this rejection. Violent action, whether in life or art, was seen as the antidote to political, cultural and psychological lethargy. The stultifying feeling that *Bell'Italia* was an albatross around the neck of a new and youthful desire for change was overwhelming, and thus reckless, sublimated sexual behaviour was proposed as the true source of freedom and energy:

> 'Let's go!' I said. 'Friends, away! Let's go! Mythology and the Mystic Ideal are defeated at last. We're about to see the Centaur's birth and, soon after, the first flight of Angels! . . . We must shake the gates of life, test the bolts and hinges. Let's go! Look there, on the earth, the very first dawn! There's nothing to match the splendour of the sun's red sword, slashing for the first time through our millennial gloom!'
>
> We went to the three snorting beasts, to lay amorous hands on their torrid breasts. I stretched out on my car like a corpse on its bier, but revived at once under the steering wheel, a guillotine blade that threatened my stomach.
>
> The raging broom of madness swept us out of ourselves and drove us through streets as rough and deep as the beds of torrents. Here and there, sick lamplight through window glass taught us to distrust the deceitful mathematics of our perishing eyes.

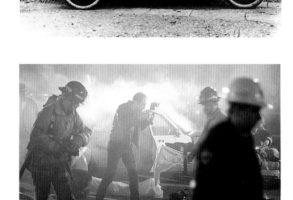

With its faintly ludicrous *Toad-of-Toad-Hall*-on-drugs tone, this celebrated passage from the Founding Manifesto of Futurism continues until, inevitably, Marinetti's car crashes into a 'maternal ditch, almost full of muddy water! Fair factory drain! I gulped down your nourishing sludge; and I remembered the blessed black breast of my Sudanese nurse'. A crowd of gawping local fishermen hastily erect a derrick and fish the car out of the ditch thinking it is beyond repair, but Marinetti caresses his 'beautiful shark' and it roars back to life.

David Cronenberg's controversial 1997 film *Crash* (fig.4), based on J.G. Ballard's novel written in 1973, shows a world of perverted desire whose characters, inverting the stereotypes of contemporary car commercials, derive a sick gratification from watching and being involved in motorway crashes. Pleasure and pain mix in a world of remorseless traffic and empty sexual craving. In Marinetti's manifesto, almost ninety years earlier, though sexuality and technology are similarly conjoined in the car crash, the sense of danger is greater than the actual catastrophe and, more significantly, it leads to the full

release of tension and to a new creative energy and determination: 'And so, faces smeared with good factory muck, plastered with metallic waste, with senseless sweat, with celestial soot – we, bruised, our arms in slings, but unafraid, declared our high intentions to all the *living* of the earth.' The famous eleven-point manifesto then follows:

1. We intend to sing the love of danger, the habit of energy and fearlessness.
2. Courage, audacity, and revolt will be essential elements of our poetry.
3. Up to now literature has exalted a pensive immobility, ecstasy, and sleep. We intend to exalt aggressive action, a feverish insomnia, the racer's stride, the mortal leap, the punch and the slap.
4. We affirm that the world's magnificence has been enriched by a new beauty: the beauty of speed. A racing car whose hood is adorned with great pipes, like serpents of explosive breath – a roaring car that seems to ride on grapeshot is more beautiful than the *Victory of Samothrace*.
5. We want to hymn the man at the wheel, who hurls the lance of his spirit across the Earth, along the circle of its orbit.
6. The poet must spend himself with ardour, splendour and generosity, to swell the enthusiastic fervour of the primordial elements.
7. Except in struggle, there is no more beauty. No work without an aggressive character can be a masterpiece. Poetry must be conceived as a violent attack on unknown forces, to reduce and prostrate them before man.
8. We stand on the last promontory of the centuries! . . . Why should we look back, when what we want is to break down the mysterious doors of the Impossible? Time and Space died yesterday. We already live in the absolute, because we have created eternal, omnipresent speed.
9. We will glorify war – the world's only hygiene – militarism, patriotism, the destructive gesture of freedom-bringers, beautiful ideas worth dying for, and scorn for woman.
10. We will destroy the museums, libraries, academies of every kind, will fight moralism, feminism, every opportunistic or utilitarian cowardice.
11. We will sing of great crowds excited by work, by pleasure, and by riot; we will sing of the multicoloured, polyphonic tides of revolution in the modern capitals; we will sing of the vibrant nightly fervour of arsenals and shipyards blazing with violent electric moons; greedy clouds by the crooked lines of their smoke; bridges that stride the rivers like giant gymnasts, flashing in the sun with a glitter of knives; adventurous steamers that sniff the horizon; deep-chested locomotives whose wheels paw the tracks like the hooves of enormous steel horses bridled by tubing; and the sleek flight of planes whose propellers chatter in the wind like banners and seem to cheer like an enthusiastic crowd.

That the outcome of Marinetti's crazy, phallic drive through the night in his sex machine should be expressed in the classic political form of a manifesto, as well as in the announcement of a new, at this stage literary, movement is important to note. Although in a sense Marinetti is driving his libido towards a brave new world of the future, anticipating the notion that the car is a symbol of personal freedom, the key motive is the race from the atavistic pull of the past and the engagement of present desire with present reality. Spaceships might or might not follow.

3

F.T. Marinetti in his automobile 1908

4

Still from *Crash* (1997), directed by David Cronenberg

2

THE CONDITIONS FOR FUTURISM

In 1909 Italy was still a very young nation and one ill at ease with its past as well
as its present and anticipated future. The country's economy was growing
rapidly, and a powerful, if precarious, sense of nationhood had developed.
Futurism was an intrinsic part of this volatile context, and its strengths and
weaknesses as a movement derive in large part from the national circumstances
in which it evolved. It was also self-consciously international in its ambitions:
its relations with the avant-garde culture of other parts of Europe, as well as its
response to the host of scientific and technological changes that were
dramatically altering people's experience across the world, are key factors for an
understanding of its particular character. This chapter will give a brief account
of some of the most important elements forming the background to Futurism.

In 1861, after forty years of political struggle, the fragile new state of Italy
was proclaimed. This often violent progress towards nationhood had been part
of a wider European development, which saw, in Germany for example, new
political structures and cultural identities forming under the pressures of
unavoidable economic, technological and social change. In Italy unification was
not immediate and absolute. The new king Vittorio Emmanuele III and his
government were based in Turin and Piedmont, and their powerful elite in the
north dominated the new country. The extraordinary Vittorio Emmanuele II
monument, built provocatively at the heart of the ancient papal state of Rome
as the 'altar of the nation' and known to many Romans as 'The False Teeth', was
a grandiose, almost burlesque statement of this new power (fig.5). Its

gargantuan marble pretensions express many of the contradictory forces at work in modern Italy, which the Futurists would later seek to harness. The financial circumstances of the country overall were almost continuously parlous and the heavy taxes necessary to balance the national budget created enormous discontent, especially in the poorer areas of the south. While the great industrial cities of Milan, Turin and Genoa expanded enormously under a liberal regime, other areas remained economically disadvantaged and the strains of this imbalance between the regions led to a dangerous fragmentation at the political level. By the 1880s, its problems exacerbated by a global depression, Italy was facing widespread poverty and the ensuing disillusion and discontent led to the formation of many political groups in urban and rural areas prepared to take violent action to fight their cause in the absence of a wider franchise. The artist Pelizza da Volpedo, an important precursor of the Futurists, portrayed the organised power of the masses in his huge canvas *The Fourth Estate* (fig.6). By the 1890s, government measures expanding the electorate, protecting domestic economies, providing subsidies and increasing investment

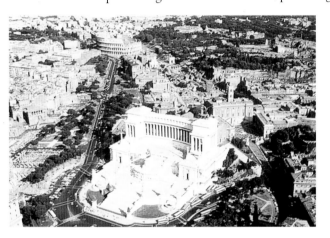

led to a marked improvement in the economy, although the action taken still favoured the industrial north and left the agrarian south in a state of near crisis.

In the sphere of international policy the government began a period of colonial expansion in Africa, hoping to achieve a nationalist consensus and to extend markets for the growing home economy. Although both aspirations were severely limited by the sheer range and power of the imperial interests of Britain, France and Germany, it was of utmost importance for Italians to demonstrate on a world stage that they were part of the 'aristocracy' of European nations. Such attitudes were later to become part and parcel of Futurist propaganda as it sought to take a specifically Italian variety of modernism to the rest of the continent and beyond.

The authoritarian administration of Francesco Crispi in the late 1880s and early 1890s created corruption at the highest levels of government and society as well as the suppression of the new reformist Socialist Party. When Italy was defeated by the Abyssinians at the Battle of Adua in 1896, however, Crispi's days were numbered and Giovanni Giolitti came to power. Giolitti pursued moderate policies, which were designed to ensure greater stability and steady economic growth and were underpinned by a move to greater consensus among different classes and interest groups. He further extended the franchise, although he always operated with a minority, and introduced a wide range of legislation intended to ameliorate social and political inequalities and conflict. The fact that he was the figurehead of Italy's *belle époque* made him vulnerable to charges of decadence and corruption by his radical enemies.

Giolitti's problem was the continued prevalence, in spite of his reforms, of small but determined marginal groups of anarchists, syndicalists, nationalists and extreme socialists who disapproved of his pragmatic compromises and lack of radical vision. From many of these groups there emerged a broad though disunited movement demanding a nationalistic, expansionist, corporate state. War and social integration were seen by those supporting this tendency as two of the crucial impetuses for national rejuvenation. Young intellectuals and artists, attracted by this dynamic ideology, became fierce opponents of Giolitti and sought political ideas and cultural forms with which to express their impatience and frustration. Marinetti, who preferred the colonialism of Crispi, was no doubt one of those discontented readers of the magazine *La Voce* who would have enthusiastically agreed with the writer Giovanni Amendola's critique of *Giolittismo* in 1910, when he wrote: 'Disgust and pity fills us when we look back over the past decades of political and administrative life in our

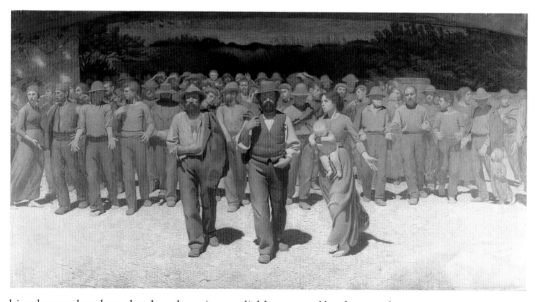

kingdom and see how they have been irremediably stamped by the moral deficiency and intellectual poverty of our ruling class. With impatience and anger do we take stock of the enormous obstacles which we have to remove from the path that will lead our people towards a national life in tune with our present ideals and needs.' This sense of betrayal should not be underestimated and it explains the strength of the vision held by many intellectuals that a profound reorganisation of Italian society based on entirely new philosophical premises was urgently required. The violence of the language indicates the strength of feeling that, as we have already seen, was to become a hallmark of Futurist rhetoric. Typical of the literature of this political culture, for example, was the journal *La Demolizione*, edited by Ottavio Dinale, dedicated to 'vast social battle' and publisher of Marinetti's Futurist manifesto. Giolitti, his parliament, government and supporters among the industrialists and landowners, so Dinale believed, would be crushed in the same way that Italy's stifling and humiliating cultural dependency on its 'dead' museum culture

would be demolished to make way for the new art of the future. The struggle to define the nature of this new art was at the heart of the Futurist project. When Mussolini's Fascist state seized power following the 'March on Rome' in 1922, the embodiment so it seemed of these earlier expressions of political and cultural renewal, it also inherited all the uncertainties and contradictions in the artistic and cultural sphere, which, as ever, remained unresolved. Futurism and Fascism were indissolubly linked, as we shall see, but in a subtly strained, puzzling and even comic relationship. Mussolini promoted certain aspects of Futurism while remaining extremely wary of, and even openly hostile to, others.

This turbulent political background specific to Italy should also be considered against a wider set of conditions that were affecting all Europeans, and indeed the inhabitants of many other countries, in less definite but nevertheless real ways in the years around the turn of the twentieth century. The writer Stephen Kern has described 'a series of sweeping changes in technology and culture [that] created distinctive new modes of thinking about and experiencing time and space. Technological innovations including the telephone, wireless telegraph, x-ray, cinema, bicycle, automobile, and airplane established the material foundation for this reorientation; independent cultural developments such as the stream-of-consciousness novel, psychoanalysis, Cubism, and the theory of relativity shaped consciousness directly. The result was a transformation of the dimensions of life and thought.' The Futurists in particular were keen to 'shape consciousness directly' in the light of such changes. Their vision of a new Italy was grounded in the material and cognitive experience shared to a greater or lesser extent by all their fellow countrymen. They were certainly not alone in observing the significance of these new conditions, but they approached them with an aesthetic and intellectual purpose that was unique in its focus and technical means.

Many of these aspects of the early Futurist culture are best discovered and examined through the artworks and writings of the figures we shall be discussing in subsequent chapters. However, there are certain areas that require a degree of amplification at this stage because they lie at the core of the general consciousness of the international audience to which the Futurists directed their practices.

Firstly, the changes in the means and speed of communication had profound effects. Aside from steam-powered ships and trains, motorcars and, most recently, aeroplanes, one of the most important changes arrived with the development of wireless telegraphy. In 1894 the Italian Guglielmo Marconi, naturally a Futurist hero, invented an apparatus that transmitted electromagnetic waves and by 1904 his new company had established the first transatlantic wireless news company. The possibilities afforded by such technology suggested a new network of invisible waves criss-crossing the world and breaking down the slow, unilinear time of the past. With the concurrent growth of telephone usage there was a novel awareness of the world as a dynamic interaction of simultaneous events, often thousands of miles apart, but which could be experienced in an instant. The social ramifications of such developments were not lost on contemporary commentators, many of whom anticipated the 'global village' described by the Canadian cultural theorist

6
Giuseppe Pelizza da Volpedo

The Fourth Estate
1898–1901

Oil on canvas
283 x 550 (111 x 216)
Civica Galleria d'Arte
Moderna, Milan

Marshall McLuhan many years later. With photography and cinema developing during this period there was a new experience of the instantaneous and the simultaneous, which gripped many artists and writers, from James Joyce, who was instrumental in opening the first cinema in Dublin in 1909 and whose literary techniques reflected the new sense of time, to Cubist painters such as Pablo Picasso in his fragmentary canvases, and Sonia Delaunay, who illustrated Blaise Cendrars's poem *Prose on the Trans-Siberian Railway and of Little Jehanne of France* in 1913 (fig.7). This work, a two metre 'scroll', describes a train journey from Moscow to Harbin, and includes a map and an abstract evocation of the journey by Delaunay which, along with Cendrars' words, evoke a Whitmanesque world of speed, disrupted time and mechanical personal experience:

> Now I've made all the trains run after me
> Basel–Timbuktu
> I've also played the horses at Auteuil and at Longchamps
> Paris–New York
> Now I've made all the trains run alongside my life
> Madrid–Stockholm.

The railway station of a Victorian painter such as William Powell Frith had changed from being a place of arrival and departure to a point on a kaleidoscopic mental map of desire. Like the French poet and critic Guillaume Apollinaire, some of whose poetry investigated through broken syntax and rhythms the sexual fantasies embedded in the new consciousness, Marinetti and the Futurists brought to their work a sense of the libidinal energy that seemed to be driving the intricate technological and psychological changes.

Although Futurism is often equated simply with 'machismo' there were in fact a number of female Futurists, and one of them, Valentine de Saint-Point, the French poet, dancer and exponent of the need for a Nietzschean 'superwoman', wrote a 'Futurist Manifesto of Lust' in 1913, which succinctly defined the relationship between sexuality and modernity: 'LUST EXCITES ENERGY AND RELEASES STRENGTH. Pitilessly it drove primitive man to victory, for the pride of bearing back to a woman the spoils of the defeated. Today it drives the great men of business who direct the banks, the press and international trade to increase their wealth by creating centres, harnessing energies and exalting the crowds, to

7
Sonia Delaunay
Prose on the Trans-Siberian Railway and of Little Jehanne of France
1913
Paper 195.6 × 35.6
(77 × 14)
Tate Gallery

8
Luigi Russolo
Nietzsche and Madness
1907–8
Etching
Civica Raccolta delle Stampe Achille Bertarelli, Castell Sforzesco, Milan

worship and glorify with it the object of their lust.' Machines, the 'life-force', capitalism and a violent sexual impulse were inextricably linked in the Futurist imagination with historical forces against which they believed it was futile to struggle.

The Futurists were mainly artists and writers and thus their interest was to present this wholly unprecedented range of new experiences in their work, focused by a sense of their historical mission as the avant-garde of a rejuvenated Italy. They were unusually promiscuous in their pursuit of ideas and images and happily plundered the efforts of many others as they gathered the elements of Futurist art into a coherent and distinct synthesis. There were, however, two thinkers whose ideas were particularly significant in the formation of Futurism and, indeed, in the development of early modernism as a whole: Friedrich Nietzsche (1844–1900) and Henri Bergson (1859–1941).

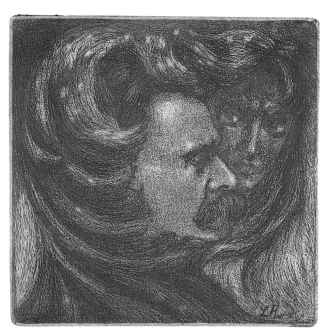

Nietzsche, celebrated for having announced in 1882 the 'death of god', has suffered from selective misinterpretation by detractors and disciples alike. The Futurists were disciples and duly misread Nietzsche for their own particular purposes (fig.8). Nietzsche's philosophy, written in a hybrid, aphoristic style in works such as *Thus Spoke Zarathustra* (1883–5) and *The Will to Power* (1887), attempted to break through the fragmented rationalism of modern culture and morality, to go 'beyond good and evil'. His rejection of Christianity and return to the culture of classical Greece demanded that the modern individual create his own system of values. In *The Birth of Tragedy* (1872) he contrasted the 'Apollonian' spirit, which is based on order and reason, with the 'Dionysian' – that which draws on the deep and chaotic forces of life and in which modern man should immerse himself. From this supreme 'will to power' would emerge the 'superman', the man who transcends the limitations and mediocrity of the contemporary world and who rises above the crowd. Ultimately, this individual would be the heroic artist: 'only as an aesthetic phenomenon is the world and the existence of man eternally justified.' Art, in Nietzsche's version of things, is the product of a restless, tragic, Dionysian soul that constantly recreates the world in aesthetic form and in doing so destroys the deadening accretions of the past. The artist spins an endless web of illusory form, which eventually becomes the habit of others. He is a kind of displaced leader in a god-less world radically disorientated by modernity: 'What were we doing when we unchained this earth from its sun? Whither is it moving now? Whither are we moving? Away from all suns? Are we not plunging continually?

Backward, sideward, forward, in all directions? Is there still any up or down? Are we not straying as through an infinite nothing? Do we not feel the breath of empty space?' The Futurists, among many others, sought to (mis)interpret Nietzsche's vision and to realise in themselves the concept of the superman. Similar ambitions led to more catastrophic outcomes in the cases of Hitler and Mussolini.

Whereas Nietzsche concerned himself with the idea of new values, the French philosopher Henri Bergson reconceived ideas of time and 'becoming'. In his important early book *An Introduction to Metaphysics*, published in 1893, he described time as a flux through which human consciousness flows and evolves even while the individual personality retains in this process its unique selfhood. Bergson, at pains to stress the difficulty of expressing his ideas, called human experience through time 'duration'. He distinguished between two modes of knowledge: the 'relative', which seeks to know something by external observation and analysis, and the 'absolute', which, by 'intuition', is achieved through a kind of intellectual sympathy with the inward reality of an object.

Thus, for Bergson, mechanical clock time was antithetical to 'duration' and the clock itself the rigid symbol of a kind of death-in-life. Hailing the intuitive faculties of the artist (and, incidentally, the insect) and the potential of new forms of art to flow with dynamic flux, where we 'will see the material world melt back into a single flux, a continuity of flowing, a becoming', Bergson, ironically, took a poor view of the many avant-garde artists among his army of admirers who sought to produce art out of theory.

Bergson's lectures at the Collège de France in Paris and on extensive European tours before the First World War were enormously popular with a wide-ranging audience (fig.9), which included artists such as Wyndham Lewis, writers like Marinetti and Apollinaire, and the influential syndicalist political theorist Georges Sorel, as well as an enthusiastic general public. Bergson's most successful and widely read book was *Creative Evolution* published in 1907. Following the ideals of Charles Darwin, it characterised evolution in terms of a life-force that, like an exploding shell shot from a gun, continues to fragment and to create different life forms from plants to human beings. He believed that this dynamic process could slow down and that the machine was startling evidence of this tendency. As we shall see, Bergson saw laughter as the vital internal response of man to this danger of mechanisation. His complex ideas were interpreted in many contradictory ways by a diverse audience, but he set forth a constellation of themes and a richly suggestive vocabulary that dominate the intellectual discourse of the period before 1914. Duration, intuition, evolution, the life-force, habit – all these terms occur throughout the dense web of discussions between artists, writers and theorists and affected all levels of thought and creativity in Europe.

THE PAINTERS: FIRST RESPONSES

'If our pictures are Futurist, it is because they are the result of absolutely Futurist conceptions, ethical, aesthetic, political, social', claimed the Futurists in the catalogue for an exhibition held in London in 1912. Marinetti's call for a new art was met by a number of Italian painters who responded to the vague but stirring language of the manifesto. We have seen that such language was not produced in a vacuum but was part of a disparate radical agenda for political and cultural change shared by the avant-garde intellectuals of the period. Giacomo Balla (1871–1958), Umberto Boccioni (1882–1916) and Carlo Carrà (1881–1966), among others who signed the 'Manifesto of the Futurist Painters' in 1910, were already inclined to an interest in the heated, *fin-de-siècle* fantasy mixed with modernist machine-worship and extremist political rhetoric of Marinetti's manifesto. Each of them had developed practices as painters in response to the complex options available to them at the end of the century – Social Realism, Symbolism, Impressionism and neo-Impressionism being just a few of the international styles within which their art had been formed. Most of these technical movements had broader values and political beliefs attached to them. One of the most important of these was a Nietzschean conviction that the artist and his work had a significance beyond the studio, salon or museum and that the artist's vision was at a critical 'cutting edge' that set the pace for society's development. Thus the 'avant-garde', by definition, was ahead of the rest of mankind, the latter, as it were, catching up, reluctantly but inevitably, with the pioneering vision.

Balla's pre-Futurist painting reveals an artist with a strong commitment to

socialist politics and to the depiction of the working class, the dispossessed and the marginalised in society, such as bankrupts and the insane. In *A Worker's Day*, painted in 1904 (fig.10), he divides the canvas into three to show, in a manner indebted to Claude Monet's famous series of Impressionist paintings of the same subject in changing light, three moments during the working day of some building labourers. The frame is painted to look like brickwork, which both illustrates the nature of his subjects' work and emphasises the theme of construction – a theme, along with the depiction of change through time, that features prominently in Futurist art. While there is some reference to traditional images of the cycle of work, seen here under evolving light conditions, there is a strong, if melancholy, sense of modernity in the geometrical formation of the building under construction and the impression of human life ordered by the determining physical and psychological grid of urban life.

Street Light (fig.11), probably painted by Balla in 1909 (though the dating is uncertain), was inspired by one of the first electric street lamps to be installed in Rome where he was based, and was probably an initial response to Marinetti's manifesto and other contemporary writing. It deliberately juxtaposes the rays violently discharged in multi-coloured darts by the street light with a rather feeble crescent moon that seems to be circling it. Balla may have been inspired in this modest, but crudely effective painting by Marinetti's early Futurist prose piece 'Let's Murder the Moonlight' of April 1909, in which he described a typically fantastic midnight escapade:

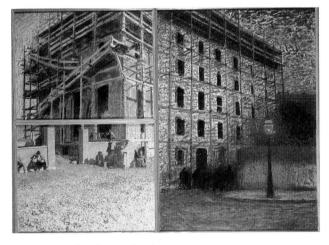

> A cry went up in the airy solitude of the high plains: 'Let's Murder the moonlight!' Some ran to nearby cascades; gigantic wheels were raised, and turbines transformed the rushing waters into magnetic pulses that rushed up wires, up high poles, up to shining, humming globes.
>
> So it was that three hundred electric moons cancelled with their rays of blinding mineral whiteness the ancient green queen of loves.

Here, the contemporary electrification of Italy evokes a man-made or masculine light source that overcomes the feminine power of the moon, the mythical source of the sea's rhythm, love and madness. The hidden theme of 'scorn for woman' is significant. For Marinetti and many of the Futurists, 'Woman' was 'anti-modern' and resisted change. However, this apparently misogynist tendency should be seen against a broader Futurist ambition to create 'a non-human type'. As the literary critic Peter Nicholls has pointed out: 'Although Marinetti's fantasy of a new heroic existence amounted to a dream of super-masculinity, it thrived on the "paradox" that the lack and inadequacy which it aimed to abolish were the entailments not merely of traditional

10
Giacomo Balla

A Worker's Day 1904

Oil on card 100 × 135
(39½ × 53)
Private Collection

11
Giacomo Balla

Street Light 1909

Oil on canvas
174.7 × 114.5
(68¾ × 45¼)
The Museum of Modern
Art, New York. Hillman
Periodicals Fund

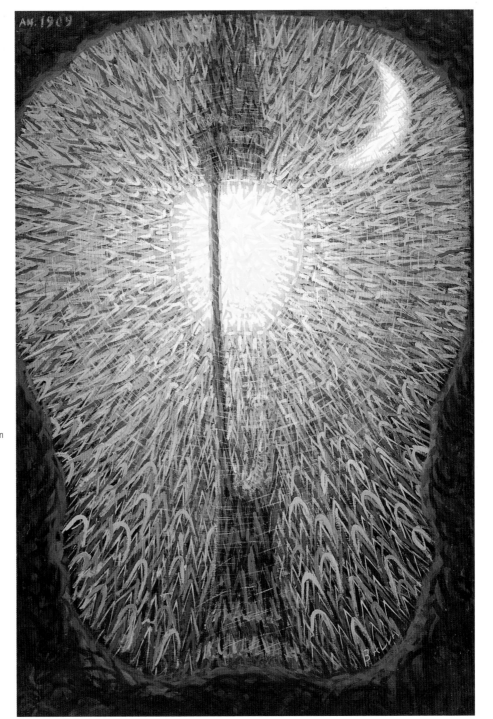

femininity but of sexual difference itself.' Marinetti had written in 1909 in the magazine *Poesia* of 'the terrible nausea we get from the obsession with the ideal woman in works of the imagination, the tyranny of love amongst Latin people'. Thus we can see how Balla's painting carries a weight of complex, even contradictory, cultural concerns beyond questions of technique or stylistic appropriation.

Umberto Boccioni, who was Balla's student in Rome at the turn of the century, shared the older artist's socialist and humanitarian vision and the concomitant idea that humans are the product of their environment. He was also a devotee of Nietzsche, whose writings, as we have seen, were crucial to Futurist thinking. In Balla's studio Boccioni learned the principles of Divisionism, the Italian version of French neo-Impressionism, in which small dots, patches and lines of pigment are organised with quasi-scientific precision to emulate natural light and atmosphere.

After a period travelling in Europe, Boccioni returned to Italy and finally settled in Milan in 1907. He had begun to renounce what he saw as the

12
Umberto Boccioni

Factories at Porta Romana 1909

Oil on canvas
75 × 145
(29½ × 57)
Banca Commerciale
Italiana, Milan

13
Carlo Carrà

Leaving the Theatre
1910–11

Oil on canvas
69 × 91
(27 × 35¾)
Estorick Foundation,
London

limitations of Balla's realist aesthetic and, under the influence of the painter and colour theorist Gaetano Previati, turned to a personal version of Symbolism, which was also indebted to the art of the Norwegian artist Edvard Munch. By 1909, however, Boccioni had identified his art with more obviously modern interests in his subject matter and technique. Indeed as early as 1907, anticipating the spirit of the first Futurist manifesto, he had written in his diary that, 'I feel I want to paint what is new, the product of our industrial time. I am nauseated by old walls, old palaces, old subjects based on reminiscences: I want to have my eye on the life of our day'. His *Factories at Porta Romana* 1909 (fig.12) shows an industrial area on the northern edge of Milan where he lived, and continues the theme of contemporary construction and urban expansion found in Balla's *A Worker's Day* of five years earlier. Developing the Divisionist technique he had learned under Balla and Previati, Boccioni suggests the vibrant energy of agricultural land as it undergoes transformation into a suburb of factories with new roads, workers' tenements and chimneys belching smoke. It is uncertain whether this work was painted before or after the

publication of Marinetti's founding manifesto, but it is clearly engaged with the heroic industrialisation seen by contemporary radicals as a symbol of the modernisation of Italy.

Carlo Carrà who, like Boccioni, was based in Milan, had also developed during the opening few years of the century a Divisionist technique allied to a realist subject matter that he had inherited from his teacher at the Accademia di Brera in Milan, Cesare Tallone. In works such as *Leaving the Theatre* (fig.13) Carrà presents a nocturnal metropolitan world irradiated by electric light in which the spectral human figures seem to melt into a multi-coloured atmosphere where foreground and background are merged across the picture plane. The

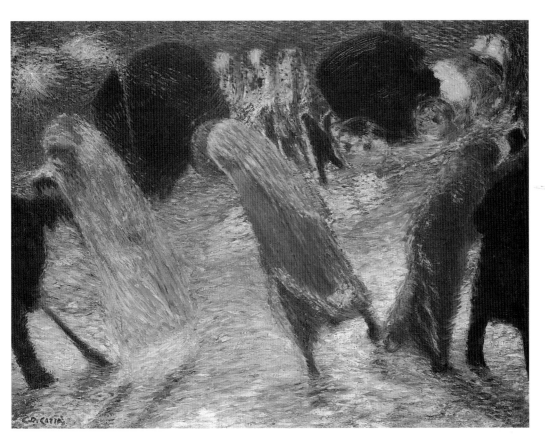

sense of anti-climax at the end of a performance is conveyed by the stooping figures as they dissolve into the night. As in much of the Futurist painting that was to follow shortly after such works as this, there is a strong tendency to subordinate the human being to the forces of the environment and to suggest a blurring of the boundaries between separate individuals and the inanimate forms surrounding them. Psychological and physical space are merged.

The signatories of the 'Manifesto of the Futurist Painters', published in a leaflet on 11 February 1910, repeated the typical Marinettian bombast about hatred of the past, the 'triumphant progress of science' and the rebirth of Italy. Artists are urged to engage their work with the modern world and to 'breathe in the tangible miracles of contemporary life – the iron network of speedy

communications which envelops the earth, the transatlantic liners, the dreadnoughts, those marvellous flights which follow our skies, the profound courage of our submarine navigators and the spasmodic struggle to conquer the unknown. How can we remain insensible to the frenetic life of our great cities and to the exciting new psychology of night-life . . . ?' The final key points of the manifesto convey a general exhortation to 'elevate all attempts at originality, however daring, however violent', without telling us much more that is helpful in identifying what the new art would actually look like.

The same painters' 'Futurist Painting: Technical Manifesto', launched at a riotous event at the Chiarella Theatre in Turin on 18 March of the same year, gives a far stronger sense of the aesthetic direction the movement would initially take as it sought to create an art in tune with Marinetti's vision. The key points are as follows:

> The gesture which we would reproduce on canvas shall no longer be a fixed *moment* in universal dynamism. It shall simply be the *dynamic sensation* itself.
>
> Indeed, all things move, all things run, all things are rapidly changing. A profile is never motionless before our eyes, but it constantly appears and disappears. On account of the persistency of an image upon the retina moving objects constantly multiply themselves; their form changes like rapid vibrations, in their mad career. Thus a running horse has not four legs, but twenty, and their movements are triangular . . .
>
> To paint a human figure you must not paint it; you must render the whole of its surrounding atmosphere . . .
>
> Who can still believe in the opacity of bodies, since our sharpened and multiplied sensitiveness has already penetrated the obscure manifestations of the medium? . . .
>
> Painters have shown us the objects and people placed before us. We shall henceforward put the spectator in the centre of the picture.

14
Umberto Boccoini

The City Rises 1910

Oil on canvas
199.3 × 301
(78½ × 118½)
The Museum of Modern Art, New York. Mrs Simon Guggenheim Fund

Thus the central point is that the modern world experienced by the city dwellers of the new twentieth century is one of movement, dynamism, transparency and radiant coloured light. The consciousness of man in this world is a restless and multi-dimensional one that 'does not permit us to look upon man as the centre of universal life. The suffering of a man is of the same interest to us as the suffering of an electric lamp, which, with spasmodic starts, shrieks out the most heartrending expressions of colour'. Man and his environment are in a constantly dynamic relationship in which 'movement and light destroy the materiality of bodies', and the medium by which this relationship will be expressed is the colour of Divisionism, 'which must be an innate complementariness which we declare to be essential and necessary'. The new Futurist painters therefore used their commitment to the chromatic fundamentals of Impressionism as the basis of an art responsive to the broad principles of Marinetti's modernist vision. They soon realised, however, that this would not be enough to deliver an art that truly reflected their complex aesthetic and psychological aspirations.

Between 1909 and 1911, therefore, we find the Futurist painters moving rapidly through a series of technical changes, which opened up for them new opportunities to create a truly radical art. Increasingly, of course, their subject

matter reflected the fascination with the characteristics of modernity expressed in their manifestos: riots, industrial labour, trams, night scenes and so on. Their colour is applied in ever brighter and more strident combinations, in keeping with their declaration that 'yellow shines forth in our flesh, that red blazes, and that green, blue and violet dance upon it with untold charms, voluptuous and caressing'.

A work such as Boccioni's large painting *The City Rises*, begun in August or September 1910 (fig.14), represents this first stage of experimentation at its height of energy and ambition. Boccioni described it the same year in a letter to his friend the critic Nino Barbantini as 'a great synthesis of labour, light and movement', going on prophetically to say that it 'may well be a work of transition, and I believe one of the last'. Hoping to create a picture that

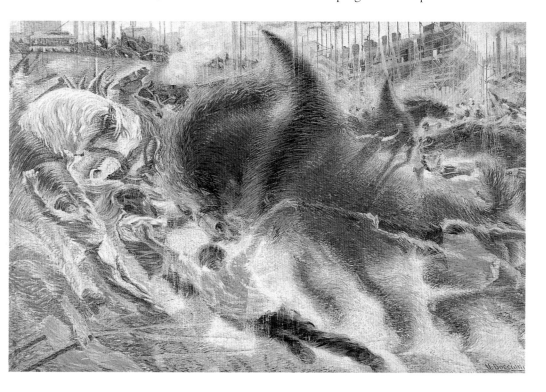

conveyed emotion through form and colour rather than mere description, Boccioni wrote to his lover Ines that, 'Now I understand the fever, passion, love, violence meant when one says to oneself: Create! . . . How I understand Marinetti's dictum: No work that lacks an aggressive character can be a masterwork'. Here are the sentiments of a true devotee of Marinetti and perhaps they also suggest a weakness in Boccioni's position. When the work was exhibited at the Arte Libera exhibition in Milan in May 1911, Barbantini wrote in an article that 'by and large it is not in accord with Boccioni's character to persist in symbolic painting'. Boccioni was wounded by this critique and replied that he had been inspired by the need to erect 'a new altar of modern life vibrant with dynamism . . . no less pure and exalting than those raised out of religious contemplation of the divine mystery'. It is certainly the case that

Boccioni painted an image of violently energetic action in a building site with labourers restraining a huge horse in the foreground while, behind them, buildings surrounded by scaffolding are being constructed and crowds and trams move through an urban landscape of chimneys and telegraph poles. The complementary colours, the dissolution of physical bodies and the attempt to force the spectator in to the 'centre' of the painting's action are all present. The sense of dynamism is enhanced by the transformation of the horse's collar into a blue vortex or propeller blade in motion. In spite of these features and the scale of the work, however, there is truth in the contention of many critics in relation to this painting, which, over the next couple of years, was exhibited across Europe and which became a 'classic' Futurist work in the public's mind, that it is a grandiose and heroic gesture rooted in late nineteenth-century Symbolism and not the herald of the brand new art form that was so clearly required by the language of the Futurists' manifestos. It was the impact of the Cubist painting of Picasso, Georges Braque and other artists based in Paris that was the decisive factor in transforming the practice of Boccioni and his colleagues during the course of 1910 and 1911. By 1912, Futurist painting had forged a new vocabulary and was able to make a serious claim to be amongst the most innovative and radical art of its time. This challenge was made known to other artists and to a curious and often hostile public through a series of exhibitions, events, manifestos and publicity stunts orchestrated by Marinetti throughout major European cities in the years leading up to the First World War.

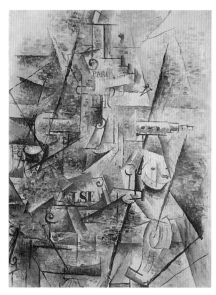

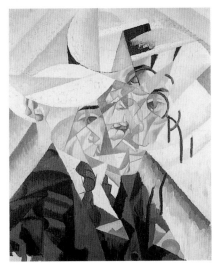

15
Georges Braque
Clarinet and Bottle of Rum on a Mantelpiece
1911

Oil on canvas
81 × 60
(32 × 23¾)
Tate Gallery

16
Gino Severini
Self-Portrait 1912–13

Oil on canvas
55 × 46
(21¾ × 18)
Private Collection

17
Umberto Boccioni
The Laugh 1911

Oil on canvas
110.2 × 145.4
(43½ × 57¼)
The Museum of Modern Art, New York. Gift of Herbert and Nannette Rothschild

Cubism had created a way of painting that completely changed the rules of the visual arts. Concentrating usually on traditional subject matter such as landscape, portraiture and, above all, still life (fig.15), the Cubists analysed form and space in such a way as to break down objects into a matrix of semi-transparent fragments in which surface and depth are no longer distinct. Facets of mute colour and broken lines were deployed to present motifs from a variety of viewpoints until, by 1910 and 1911, when the Futurists first took serious

notice of these works, the canvas offered a dense field of ambiguous signs and dappled brushwork. *Trompe-l'oeil* elements such as lettering or illusionistically painted nails were placed at intervals across the picture plane to highlight the play between the real and the artificial, which Picasso and Braque made one of the prime concerns of their new art.

Gino Severini (1883–1966), a signatory of the Futurist painters' opening manifestos, had been working in Paris since 1906, and was one of the main channels between his Italian colleagues and the new developments in the French capital. His *Self-Portrait* of 1912–13 (fig.16) shows how Cubist technique became a vehicle for a new Futurist style. While remaining committed to the

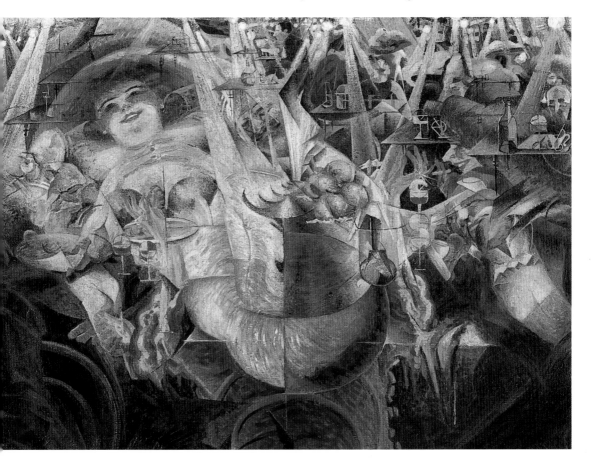

iconography of the modern world, to the concept of a dynamically interactive universe of human movement in a changed technical environment, and to the power of strong and even vulgar colour, the Futurists saw in the luminously static constructions of Cubist art the possibilities of a completely new direction for their work. Above all, it was Cubism's interpenetration of form and space, transparency and multiple viewpoints that the Futurists adapted to their own distinct ideological and imaginative interests. Although sensitive to the criticism of Italian critics such as Ardengo Soffici, who compared their early works unfavourably with those of the Cubists, they set aside nationalistic jealousies and embarked upon a period of intense experimentation. In the

18
Umberto Boccioni

States of Mind I –
The Farewells 1911

Oil on canvas
70.5 × 96.2
(27¾ × 37½)
The Museum of Modern
Art, New York. Gift of
Nelson A. Rockefeller

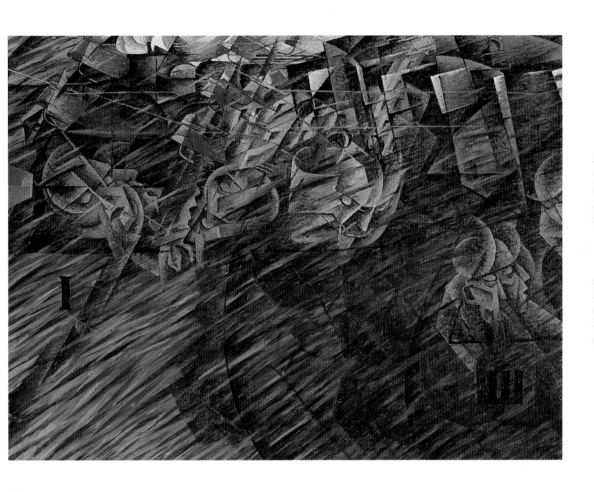

19
Umberto Boccioni

States of Mind II –
Those Who Go 1911

Oil on canvas
70.8 × 95.9
(28 × 37¾)
The Museum of Modern
Art, New York. Gift of
Nelson A. Rockefeller

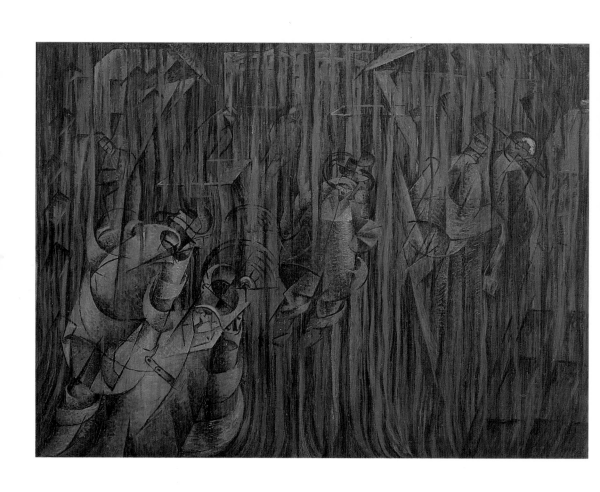

process they produced works of great visual power which, they believed, went beyond the limitations of Cubism towards a truly dynamic representation of a world of motion and emotion.

Boccioni, typically, took a deeply theoretical approach to his translation of Cubism into a distinctly Futurist mode. We have seen that the ideas of Bergson were highly influential in avant-garde circles during this period and Boccioni was exemplary in his adaptation of the philosopher's ideas to his interpretation of Cubism. In *The Laugh* of 1911 (fig.17), for example, which is the first of his paintings to show the influence of Cubism, probably after considerable reworking over a more Divisionist first effort, we not only see the artist creating a world of Bergsonian flux, intuition and memory traces, but also a commentary on the Frenchman's theory of laughter. Bergson saw laughter as a kind of organic release of tension in response to the sight of any human who has become rigid or mechanical in their behaviour and thereby ridiculous to behold. At the heart of this theory was a concept of the *élan vital*, or life-force, and its opposite, the ossified forms of dead matter. Boccioni's group of heavily made-up and bejewelled prostitutes sitting around a table in a garishly lit café explode with laughter, perhaps at the expense of the bald, moustached man on the left who seems to be grimacing uncomfortably. Fashionable Thonet chairs, glass-topped tables and large globed lights in an apparently mirrored interior are shown intersecting with the animated figures in a world of brittle egos, nervous laughter and brutal vulgarity.

It was in his *States of Mind* triptych of 1911, however, that Boccioni made his first great statement of Futurist painting, bringing his interests in Bergson, Cubism and the individual's complex experience of the modern world together in what has been described as one of the 'minor masterpieces' of early twentieth-century painting. The work is an attempt to convey feelings and sensations experienced through a passage of time, using the new means of expression described in various writings of the period. These included 'lines of force', which were intended to convey the directional tendencies of objects through space and to draw the spectator's perceptions and emotional responses into the heart of the picture; 'simultaneity', which combined memories, present impressions and anticipation of future events in an orchestrated whole; and 'emotional ambience', in which the artist seeks by intuition the sympathies and links that exist between the exterior (concrete) scene and the interior (abstract) emotion.

In the triptych, the painting subtitled *The Farewells* (fig.18) presents transparent fragments of a locomotive seen from various angles and the flowing forms of embracing figures caught up in waves of smoke, time-flow and pulsing radio signals. True to Futurist doctrine, the colours are not naturalistic but, rather, intended to exaggerate certain subjective emotional states. The image is thus a rhythmically organised hieroglyph suggestive of memory flashes, anguished feelings of separation and the excited anticipation of travel. Vulnerable human bodies and the metallic forms of the locomotive are merged in a synthesis suggestive of a heightened consciousness attempting to hold together the contradictions of the experience of time in an almost superhuman effort of will power. It is important to stress this transcendental

20
Umberto Boccioni

*States of Mind III –
Those Who Stay* 1911

Oil on canvas
70.8 × 95.7
(28 × 37¾)
The Museum of Modern
Art, New York. Gift of
Nelson A. Rockefeller

31

sense because Boccioni believed in a higher purpose in his art of creating what he called 'spiritualised objective elements' through almost mystical 'pure mathematical values' that would provide the viewer with an equivalent for the artist's state of mind. Such ambitious ideas of a new means of visual communication were shared with many avant-garde artists in Europe during this period. *Those Who Go* (fig.19), dominated by a cold, mechanical blue tone, shows the oblique force lines of the passengers' movement in the train as it speeds past a fragmentary landscape of buildings. In *Those Who Stay* (fig.20), vertical lines form a mournful green veil through which despondent figures disappear. Boccioni wrote of this part

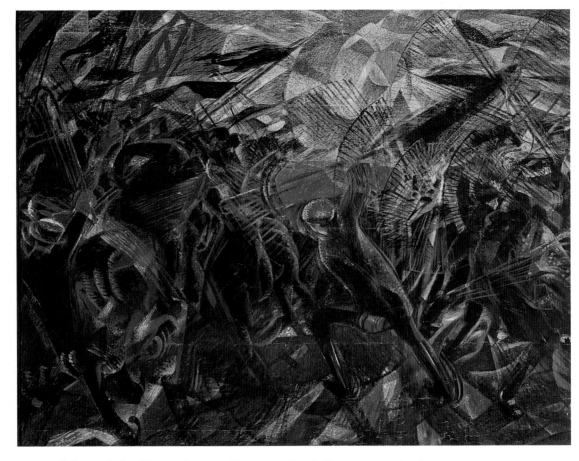

of the work that 'the mathematically spiritualised silhouettes render the distressing melancholy of the soul of those that are left behind'. This is the language of the many late nineteenth-century Symbolist theories that saw colour and form as analogous to music, but which here have been given a Futurist twist. James McNeill Whistler or Paul Gauguin would have understood the ideas, even if no doubt they would have been amazed by the visual result.

Carrà's *The Funeral of the Anarchist Galli* of 1911 (fig.21) is a large canvas commemorating a particular political incident witnessed by the artist in 1904. The celebrated anarchist had been killed during the general strike of that year

and at his funeral the police's insistence that the ceremony should take place outside the cemetery provoked a riot. Carrà, who was himself closely involved in anarchist and syndicalist politics, used this by now legendary incident as the source for a contemporary history painting that evokes the violent clash between freedom fighters and the forces of law and order as a visual manifesto of Futurist political and aesthetic convictions. Indeed, he made significant alterations to the painting before exhibiting it, in order to introduce a more Cubist and geometrical edge, thereby accentuating its radical message. While there are clearly references to Italian quattrocento artists such as Paolo Uccello (for Carrà was a keen student of his native Italian painting traditions), such historical references are subordinated to the devices of Futurist painting at a critical stage in its development. The dominant emotional mood of anger and aggression is conveyed through the reds and oranges, while a more ominous tone is present in the anarchist blacks and the deep blues of the figures. Here,

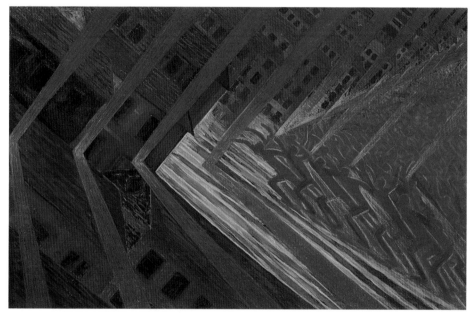

21
Carlo Carrà

The Funeral of the Anarchist Galli 1911

Oil on canvas
198.7 × 259.1
(82¼ × 102)
The Museum of Modern Art, New York. Acquired through the Lillie P. Bliss Bequest

22
Luigi Russolo

Revolt 1911

Oil on canvas
150 × 230m
(59 × 45¼)
Haags Gemeentemuseum, The Hague

the 'force lines' of the technical manifesto are used to draw the spectator into the heart of the action as Carrà attempts to politicise his audience through form and colour.

The painting makes a fascinating comparison with a work by Carrà's associate Luigi Russolo (1885–1947) of the same year (fig.22). *Revolt*, with its diagrammatic red chevrons indicating the waves of revolutionary force thrusting into the city, represents the idea of the unified masses in their struggle for power. In the spirit of the Futurist political manifestos published by Marinetti in 1909 and 1917, Russolo shows 'the collision of two forces, that of the revolutionary element made up of enthusiasm and red lyricism against the force of inertia and reactionary resistance'. Further comparison of Russolo's painting with Pelizza da Volpedo's *The Fourth Estate* (fig.6), painted a decade earlier, offers a telling insight into the extraordinary changes in Italian art over such a short period of time.

Both *Revolt* and *The Funeral of the Anarchist Galli* were shown at the Free Art Exhibition in Milan in 1911, organised by the Casa del Lavoro (House of Labour) as a charity event in aid of the unemployed. Boccioni was part of the organising committee and used the exhibition as an opportunity to promote Futurism and its ideology. In line with Marinetti's libertarian thinking Boccioni not only exhibited Futurist painting but also works by amateurs, children and workers. In a press release for the exhibition he wrote of the 'search for an art that is more ingenious, instinctive, sincere, and which returns to the healthy origins of creativity'. This art 'is not the privilege of a few, but is inborn in human nature' and is typified by 'a universal language of forms and colours ... subconsciously reflected and vividly expressed' in the work of children and proletarians 'struck by their imaginations'. Although most organised socialist groups were highly suspicious of Futurism and indeed all avant-garde art, there is little doubt that many workers in Milan and Turin were drawn to Futurism by such exhibitions. By these means, along with the usually turbulent and even incendiary lectures and Futurist *serata* (evenings) (fig.23) put on by Marinetti and his compatriots in the theatres and halls of the great industrial cities of the north, the group made sure that it was permanently in the news.

23
Umberto Boccioni
A Futurist Evening in Milan 1911
Ink on paper
Whereabouts unknown
On the stage are Boccioni, Balilla Pratella, Marinetti, Carrà and Russolo

24
Giacomo Balla
Rhythm of the Violinist 1912
Oil on canvas
52 × 75
(20½ × 29½)
Estorick Foundation, London

25
Anton Giulio Bragaglia
Balla in Front of 'Leash in Motion' 1912
Photograph
Antonella Vigliani Bragaglia Collection. Centro Studi Bragaglia, Rome

Balla, although a mentor to a number of the younger Futurists, was involved with the movement only at a distance during these early years. Based in Rome, he worked methodically during 1912 towards an art that sought to represent a scientific analysis of movement. During that year he accepted a commission to design furniture for, and to decorate the house of, Arthur and Grete Löwenstein in Düsseldorf. The unusual black and white v-shaped frame for his *Rhythm of the Violinist* 1912 (fig.24) suggests that the painting was part of this decorative scheme. Its effect on the composition is to emphasise the upward thrust of the violin, bow and musician's hands. The meticulously painted fine lines, extending, as it were, the dot of Divisionism to suggest movement, evoke a form of chronophotography. The inspiration for these works may well have been the photography of the theatre and film director Anton Giulio Bragaglia (1890–1960), who had photographed the artist the same year (fig.25), and his manifesto 'Futurist Photodynamism' (1911) as well as the famous pictures of the nineteenth-century photographers Eadweard Muybridge (fig.26) and Etienne-Jules Marey. Balla's analytical approach to the perception of external movement is not complicated by the memory traces, emotional forces and multiple viewpoints used by Boccioni and Carrà. It is, however, a complex organisation of brushstrokes that evidently suggests a musical analogy appropriate to the subject matter and gives a hint of Balla's interest in Symbolist and Theosophical ideas. In the same year Balla was also experimenting with a series

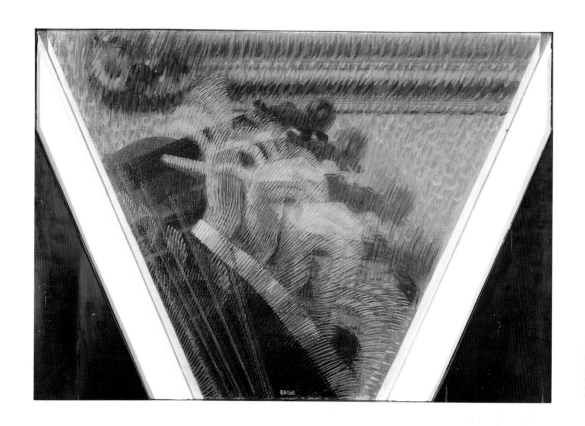

of abstract colour studies on paper and canvas, which were called *Iridescent Interpenetrations* (fig.27) and were closely related to this kind of painting and to his aesthetic theory. In these works coloured lozenges and other shapes are organised in geometrical patterns, similar to those found in the textbooks used by nineteenth-century artists such as Georges Seurat and the Italian Divisionists. Balla's intention, though, seems to have been to incite quasi-spiritual sensations in the viewer where the spectrum symbolises and effects a conjunction of complementaries, perhaps embodying Balla's response to the Futurists' demand for an 'innate complementariness' in the painter's vision. It is possible that Balla was also interested at this time in the works of the French painter Robert Delaunay whose *Windows* series (fig.28) similarly brought together scientific and mystical concerns with the power of colour.

In his sequence of paintings on the theme of abstract speed Balla became a fully fledged Futurist in his subject matter, observing, in his usual painstaking fashion, the movement of speeding cars and producing from a multitude of drawings a series of canvases in 1913 that were clearly intended to go beyond the more mechanically analytical works of the previous year. In *Abstract Speed: The*

Interpen26
Eadweard Muybridge

'Athletes Wrestling', reproduced in *Animal Locomotion* 1887

Victoria and Albert Museum

27
Giacomo Balla

Study for *Iridescent Interpenetration no.2* 1912

Watercolour on paper
22 × 18 (8¾ × 7)
Galleria Civica d'Arte Moderna, Turin

28
Robert Delaunay

Windows Open Simultaneously (First Part, Third Motif) 1912

Oil on canvas
45.7 × 37.5
(18 × 14¾)
Tate Gallery

29
Giacomo Balla

Abstract Speed: The Car Has Passed 1913

Oil on canvas
50.2 × 65.4
(19¾ × 25¾)
Tate Gallery

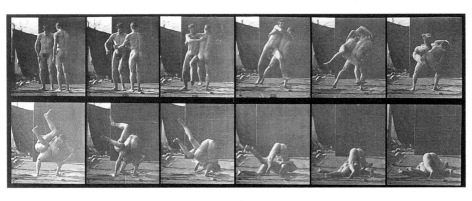

Car Has Passed (fig.29), part of a triptych, a simplified landscape provides a backdrop to a series of force lines tinged with the pink of exhaust traces that suggest the atmospheric disturbance caused by the now absent car of the central panel.

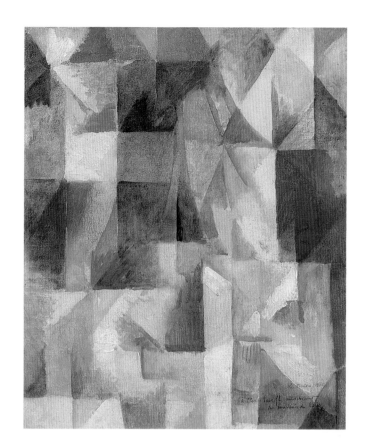

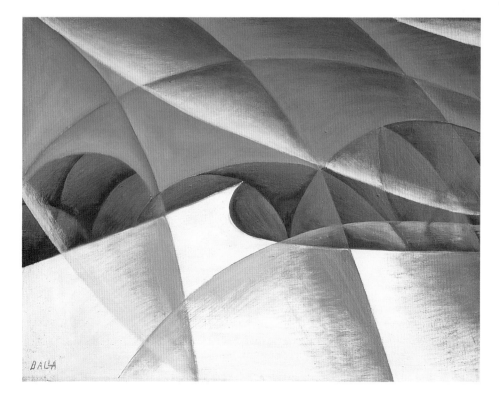

4

The Futurist Reconstruction of the Universe

Balla's overtly Futurist works coincided with an expansion of his interests in 1913 to include writing manifestos, experiments with language, theatre and fashion design and sculpture (fig.30). As with Boccioni, his art was the focus for an ambitious all-encompassing philosophy of Futurist life and his mission was to redesign the world in Futurist mode:

> The consequent merry dazzle produced by our clothes in the noisy streets, which we shall have transformed with our Futurist architecture, will mean that everything will begin to sparkle like the glorious prison of a jeweller's gigantic glass-front, and all around us we shall find aerobatic blocks of colours set out like the following word-shapes:
> Coffeeornhov Rosegreebastocap transpomotocar legcutshop blueblackwhitehouses aerocigarend skyroofliftyellight anomoviesphot barbebbenpurp.

Balla's vision here (from 'Futurist Manifesto of Men's Clothing') is that of an avant-garde consumerism. His wordplay was part of a politically motivated Futurist programme to disorientate and reorganise firstly Italian, and then all human, experience through a radical disruption of ordinary language. Drawing on late nineteenth-century French writers such as Stéphane Mallarmé and Jules Laforgue and on contemporaries such as Apollinaire and Cendrars, Marinetti, whose background was pre-eminently a literary one, had moved in his poetry, prose, drama and polemical writing towards the concept of 'Words-in-Freedom'. Turning his back on what he saw – for all their technical innovation –

30
Giacomo Balla

Page from the 'Futurist Manifesto of Men's Clothing', 1913

as the flawed romantic sentimentality of his Symbolist forebears, Marinetti declared: 'To tears of beauty brooding tenderly over tombs, we oppose the keen, cutting profile of the pilot, the chauffeur, the aviator ... We co-operate with Mechanics in destroying the old poetry of distance and wild solitudes, the exquisite nostalgia of parting, for which we substitute the tragic lyricism of ubiquity and omnipotent speed.'

Marinetti's 'Technical Manifesto of Futurist Literature' of 11 May 1912 set out a programme of syntactical revolution dictated, so he claimed, by the whirring propeller of his aeroplane as he flew over the rooftops and chimneys of Milan:

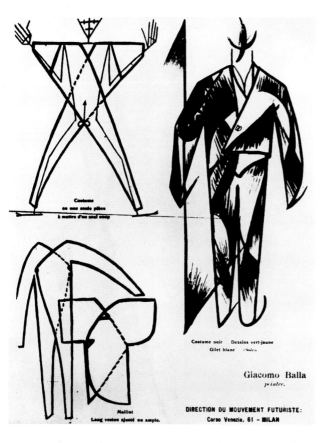

Costume
on one seule pièce
à mettre d'un seul coup

Costume noir Dessins vert-jaune
Gilet blanc (Soir).

Giacomo Balla
peintre.

Maillot
Long veston ajusté ou ample.

DIRECTION DU MOUVEMENT FUTURISTE:
Corso Venezia, 61 – MILAN

1. One must destroy syntax and scatter one's nouns at random, just as they are born.
2. One should use infinitives, because they adapt themselves elastically to nouns and don't subordinate them to the writer's 'I' that observed or imagined ...
3. One must abolish the adjective, to allow the naked noun to preserve its essential colour ...
4. One must abolish the adverb, old belt-buckle ...
5. Every noun should have its double; that is, the noun should be followed, with no conjunction, by the noun to which it is related by analogy. Example: man-torpedo-boat, woman-gulf, crowd-surf, piazza-funnel ...

He goes on to propose, among other iconoclastic gestures, the abolition of punctuation and its replacement with mathematics and musical symbols. One of his most important ideas was the extension and deepening of analogies, thus anticipating a Surrealist concept of writing: 'Analogy is nothing more than the deep love that assembles distant, seemingly diverse and hostile things ... When, in my *Battle of Tripoli*, I compared a trench bristling with bayonets to an orchestra, a machine gun to a fatal woman, I intuitively introduced a large part of the universe into a short episode of African battle.' Underpinning these technical and imaginative transformations was a new, perhaps megalomaniac concept of subjectivity. Drawing on Bergson's ideas of intuition and matter, Marinetti proposes the destruction of the 'I', 'that is, all psychology ... To capture the breath, the sensibility, and the instincts of free objects and whimsical motors'. At the heart of these ideas is a drive through 'divine intuition, the characteristic gift of the Latin races' to 'conquer the seemingly unconquerable

hostility that separates out human flesh from the metal of motors'.

These literary and language-based concepts are fundamental to an understanding of Futurist ideology. In his manifesto 'Destruction of Syntax – Imagination with Strings – Words in Freedom' of 1913, Marinetti asserts that 'Futurism is grounded in the complete renewal of human sensibility brought about by the great discoveries of science'. He expands the earlier range of Futurist devices to include the 'semaphoric adjective', 'onomatopoeia', 'typographical revolution', 'multilinear lyricism' and 'free expressive orthography'. The effect of all these newly coined terms was to open up not just the purely semantic possibilities of language but also its profoundly visual dimension. The typographical experimentation of Marinetti's celebrated book *Zang Tumb Tumb* of 1914 (fig.31) was perhaps the most successful exercise in breaking down the barriers between words and images and thus in exploding the intricate edifice of conceptual distinctions upon which, Marinetti believed, the decadent effects of tradition and convention were based. Typically, it is inspired by war, notoriously described by Marinetti as 'the sole hygiene of the world', with a cover based on the forms of the shockwaves of high explosives and an aeroplane in flight. Marinetti had acted as a war reporter during the 1912 Balkan Wars and witnessed the Bulgarian siege of Adrianopolis in October of that year. By no means a simple glorification of war, *Zang Tumb Tumb* includes a sub-atomic account of the shocks he suffered under bombardment: 'I counted the 6 milliard shocks my molecule sisters gave me I obeyed them 6 milliard times taking 6 milliard different directions.' Futurist 'simultaneous' awareness is thus not only focused on the outside world's confusion of events and on the realm of personal memory but also on the invisible world of bodily experience. Not always successful, and certainly not entirely original, Marinetti's literary experiments were nevertheless a major development in the modernist project to reconfigure creativity, consciousness and aesthetic form in the light of the profound changes in technology and science that he had identified as the driving force in twentieth-century experience.

The Futurist visual artists, whose ideas had in fact fed into Marinetti's thinking, responded almost extravagantly in their art and writing to the challenge of the high stakes raised by this literary revolution. Carlo Carrà's manifesto 'The Painting of Sounds, Noises and Smells', published in the Florentine avant-garde magazine *Lacerba* in 1913, and perhaps indebted to

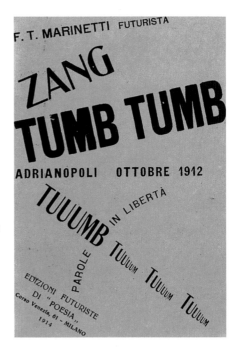

31
F.T. Marinetti
Cover of *Zang Tumb Tumb*, 1914
Tate Gallery Library

32
Umberto Boccioni
Unique Forms of Continuity in Space
1913, cast 1972
Bronze
117.5 × 87.6 × 36.8
(46 ¼ × 34 ½ × 14 ½)
Tate Gallery

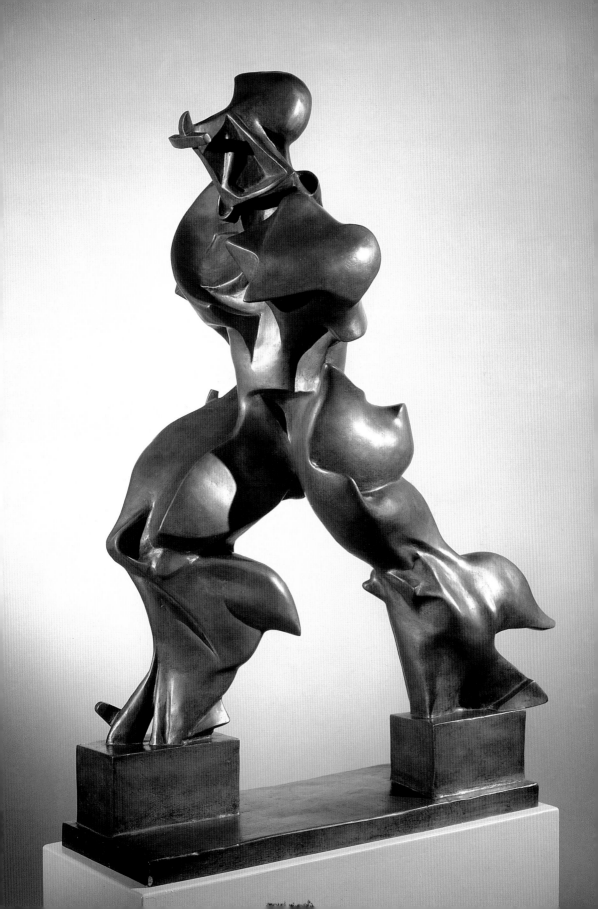

Bragaglia's photographic theories, proposed that 'sounds, noises and smells are incorporated in the expression of lines, volumes and colours ... In railway stations and garages, and throughout the mechanical or sporting world, sound, noises and smells are predominantly red; in restaurants and cafés they are silver, yellow and blue, those of a woman are green, blue and violet.' Although it is a matter of faith as to whether these highly ambitious aims were achieved in any of Carrà's paintings or in those of his colleagues, the important point here is the concept of the expansion of the visual arts into areas of experience previously denied to them.

Boccioni's sculptures of 1912 and 1913 were translations into three dimensions of his evolving painterly concerns and further evidence of the broadening of the artist's horizons at this time. His theoretical writings, and the works they sought to explain in a dense, almost poetic prose, were perhaps the most complex and sophisticated synthesis of the broad Futurist theory of art and life with the ideas of Bergson and the demands of the plastic arts. The core of his theories was the notion of 'dynamism', which he explained as 'the lyrical conception of forms, interpreted in the infinite manifestations of the relativity between absolute motion and relative motion, between the environment and the object which come together to form the appearance of a whole: environment + object'. By 'absolute motion' Boccioni meant the invisible internal forces of an object, which the artist reveals in relation to its relative motion – that which it undergoes in movement through space. His sculpture *Unique Forms of Continuity in Space* 1913 (fig.32) bravely attempts to realise what he insisted were not 'crazy abstractions'. New minds could mean new bodies.

A number of earlier sculptures by Boccioni had rather literally combined the fragmented forms of a moving human figure with 'environmental' features such as houses and window frames. In accordance with his theories, atmosphere and space, object and force lines are transmitted one to the other, and thus by implication break down the barriers between subject and object. He had described his confused state while making these pieces in a letter to Severini (November 1912), with whom he had visited the studios of Alexander Archipenko, Constantine Brancusi and other Parisian sculptors: 'And then I am struggling with sculpture: I work work work and don't know what I am producing. Is it interior? Exterior? Is it sensation? Is it delirium? Is it mere brain? Analysis? Synthesis? What the hell it is I simply do not know! Forms on forms ... confusion.' Here is the authentic voice of the heroic Futurist, nearly deranged in his commitment to invention and the destruction of old formulae. Even Medardo Rosso, the pioneering Impressionist sculptor so much admired by the Futurists for his wax images of moving figures, was rejected by Boccioni as *passé* and too concerned with the discrete figure observed from one angle (fig.33).

Unique Forms of Continuity in Space was initially modelled in plaster and a number of bronzes were cast from this original many years after the artist's

death. It is an almost baroque image of the man of the future, not only shown as a muscular form moving with awesome power through space, but also as a new type of being actually evolving through time into something beyond the human. Here, surely, is a statue, drawing heavily on the Hellenistic winged *Victory of Samothrace* in the Louvre, dedicated to Nietzsche's concept of the 'superman', who seems to become a semi-mechanised, bionic creature. If he could speak it would no doubt be in 'Words-in-Freedom'.

Futurism as an all-embracing movement in art and life, intent on 'a reconstruction of the universe' went far beyond painting and literature. Following Francesco Balilla Pratella's 'Manifesto of the Futurist Musicians' (1910), which had attacked *bel canto* and Italian opera and proclaimed the advent of atonality and irregular rhythms, Russolo published 'The Art of Noises' in 1913. He was proud of the fact that he was not a trained musician, claiming this

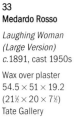

33
Medardo Rosso

Laughing Woman
(Large Version)
*c.*1891, cast 1950s

Wax over plaster
54.5 × 51 × 19.2
(21½ × 20 × 7½)
Tate Gallery

34

Luigi Russolo and his
assistant Ugo Piatti
with Noise Intoners

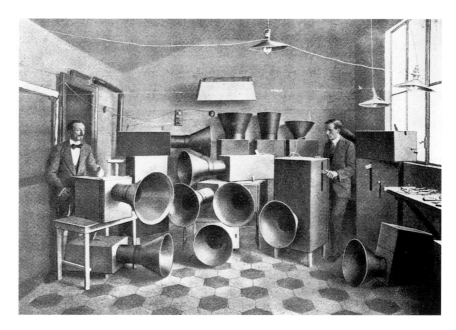

would allow him to achieve a 'great renewal' of music through a response to the noises of the modern world:

> Let us cross a great modern capital with our ears more alert than our eyes, and we will get enjoyment from distinguishing the eddying of water, air and gas in metal pipes, the grumbling of noises that breathe and pulse with indisputable animality, the palpitation of valves, the coming and going of pistons, the howl of mechanical saws, the jolting of a tram on its rails, the cracking of whips, the flapping of curtains and flags.

While a number of late nineteenth- and early twentieth-century musicians had experimented with the relationship between colour and music – A.W. Rimington's 'Colour Music', Arnold Schoenberg's dialogue with the Expressionist painter Wassily Kandinsky, and the composer Alexander Scriabin's 'Colour Organ' being typical examples – Russolo's innovation was to

go beyond conventional sources and techniques and, so to speak, 'tune-in' to the aural landscape of the modern world. To achieve his 'art of noise' Russolo devised a new form of notation and invented a range of machines that would reproduce the six varieties of noises he had defined in his manifesto. These *Intonarumori* (Noise Intoners) (fig.34) included 'Exploders', 'Cracklers', 'Gurglers', 'Buzzers' and 'Scrapers'. Russolo and his assistant Ugo Piatti toured Italy and other European countries and gave performances of works such as *The Awakening of a City* and *Meeting of Automobiles and Aeroplanes* to enraged, bemused and enthralled audiences. Russolo's extraordinary new music, which he continued to perform in the 1920s, had a dramatic effect on other composers

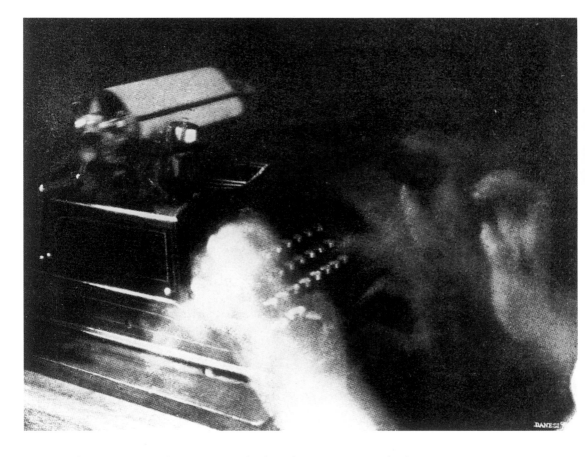

such as Igor Stravinsky, George Antheil, Arthur Honegger and Edgar Varèse. Sadly, none of his *Intonarumori* have survived.

We have seen the extent to which Balla responded to photography as a source for new approaches to painting. The fact is, however, that Boccioni, Carrà and other painters had shown little obvious interest in the camera and indeed were often actively hostile to it. Bragaglia's 'photodynamism', theoretically indebted to Bergsonian ideas of flux and synthesis, had been a bold attempt to use long exposures and other techniques to capture what he called the 'algebra of movement' and to convey an occult sense of the spiritual traces left by bodies in motion (fig.35). Bragaglia also referred to the possibility

of evoking smells through photography, which he left mysteriously unexplained, but which nevertheless reminds us of the interest in the possibilities of synaesthesia among artists of this period. As with the painters and musicians, Bragaglia's version of Futurism was a movement that embraced modern technology, spiritual and paranormal phenomena and the concept of art integrated into life. Where Russolo sought to orchestrate industrial production, and Boccioni attempted urban symphonies of colour and movement, Bragaglia moved inevitably towards the most powerful art form of the twentieth century – cinema.

In 1916 Bragaglia, whose father had been an early pioneer of Italian cinema, set up his own film company and made four films. Only one of these has survived. With starkly geometrical backgrounds designed by Enrico Prampolini, *Thais* (1916) is a melodrama of tragic love and suicide in which dissolve effects, fragmentary captions of lines by Baudelaire and blue and

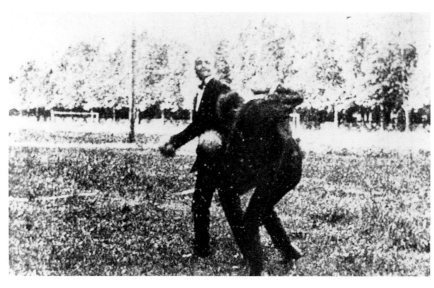

35
Anton Giulio Bragaglia

Typist 1911

Photograph
Antonella Vigliani
Bragaglia Collection.
Centro Studi Bragaglia,
Rome

36
Arnaldo Ginna

Still from *Vita Futurista*
1916

orange colour toning evoke a claustrophobic atmosphere of emotional obsession.

In 1910 Arnaldo Ginna and his brother Bruno Corra painted colour on to four rolls of celluloid film untreated with silver nitrate. Inspired, in turn, by a painting of Giovanni Segantini, a song composed by Felix Mendelssohn, a poem by Mallarmé and the complementary colours red and green and blue and yellow, the two brothers were among a number of others, including Léopold Survage in Paris, who were finding remarkable possibilities in the new medium. In 1916, at the invitation of Marinetti and with the help of, among others, Balla and Emilio Settimelli, Ginna made the film *Vita Futurista*; although it is now lost, the surviving descriptions and stills (fig.36) suggest that it continued the attempt to use the movie camera in a way analogous to other forms of Futurist experimentation. Following the compressed acts and abrupt changes of Marinetti's Futurist Variety Theatre, the film is divided into episodes with titles

such as 'How a Futurist Sleeps', 'Morning Gymnastics' and 'Futurist work'. Scenes within these episodes such as 'Balla falls in love with a chair and a footstool is born' and 'invasion of a passéist tea-party – conquest of women' indicate the slapstick and surreal character of the film, which Ginna claims was a nightmare to produce on account of the absurd and irresponsible behaviour of the Futurist actors. In spite of this, the evidence is that *Vita Futurista* constituted a remarkable moment in the early history of cinema. Using devices such as split screens, mirrors, bizarre combinations of objects and colour toning to evoke 'states of mind', Ginna and his anarchic colleagues sensed in the new technology of film an opportunity to realise the full ambition of Futurist ideas. Strangely, the promise of a Futurist cinematic *gesamtkunstwerk* was never realised. Other than fragmentary documentation, only the inspired and boastful manifestos and a legacy of avant-garde cinema by later film-makers bears witness to that promise: 'Thus we can break up and recompose the universe according to our marvellous whims, multiplying the force of the Italian creative genius and its absolute pre-eminence in the world.'

ARCHITECTURE

Futurist art, where it was concerned with the built environment, drew upon the urban realities of the great Italian cities such as Milan and Turin, which had grown rapidly during the late nineteenth century. This was a world of brick and stone embodied in traditional and classical forms. For Marinetti, however, it was not appropriate that the violent excitement of modern life should be projected onto such an anachronistic setting. The setting needed to be recreated. Firstly, inevitably, there had to be a total destruction of the old cityscape. As early as April 1910 Marinetti and his accomplices had thrown, it was claimed, nearly a million leaflets, 'Against Passéist Venice', from the top of St Mark's campanile and on to a passing crowd below:

> Let us burn the gondolas, rocking chairs for Cretins and raise to the heavens the imposing geometry of metal bridges and howitzers plumed with smoke, to abolish the falling curves of the old architecture.
> Let the reign of holy Electric Light finally come, to liberate Venice from its venal moonshine of furnished rooms.

Marinetti bellowed an improvised speech at the crowd, denouncing the decline of Venice, while his supporters, including Boccioni, Russolo and Carrà, applauded him and involved themselves in skirmishes with angry opponents, excited and angered by the Futurists' provocations.

The next, more difficult stage would be the creation of Futurist cities. While Carrà and Boccioni had hinted in their manifestos at the need for a new kind of architecture, their ideas, inevitably, were founded in their practices as painters and lacked the focus necessary for a radical departure in building and urban planning. It was a young Milanese architect, Antonio Sant'Elia (1888–1916), an ex-employee of the Technical Office of Milan's City Council, who provided the vision. Influenced initially by Viennese modernists such as Otto Wagner and

37
Antonio Sant'Elia

Electric Power Plant
1914

Pencil and inks
on paper
31 × 20.5
(12¼ × 8)
Private Collection

Adolf Loos, Sant'Elia had formed a group of architects, 'Nuove Tendenza' (New Tendency), whose first major exhibition was held at the Famiglia Artistica in May 1914. The drawings by Sant'Elia (fig.37) and his friends, such as the Swiss architect Mario Chiattone, marked a dramatic change in their aesthetic from an elaborately decorative Art Nouveau style to a streamlined modernity where the vertical straight line defined the energy and severity of the 'New City', soon to become the 'Futurist City'. Impossibly utopian as they were, the drawings powerfully expressed a new aesthetic and contained the seeds of a social and political vision in tune with Marinetti's polemics.

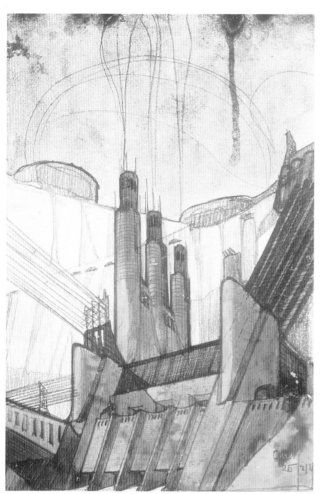

Sant'Elia's skyscrapers, railway stations, power stations and airfields (envisaged in steel, reinforced concrete, plate glass, cardboard and other new materials) were part of an integrated plan for the corporate rationalisation of modern Italy. All forms of energy, natural and human, would be harnessed into an ever-changing power-house of a multi-level city which, in its dynamic structure, would deny the past's stranglehold over change. Sant'Elia aimed at an impermanent, renewable architecture, fully in accord with Bergsonian concepts of creative evolution and Marinetti's demand for perpetual revolutionary transformation.

Sant'Elia's 'Manifesto of Futurist Architecture', published in *Lacerba* in August 1914, and almost certainly edited by Marinetti, begins by conducting the usual assault on the past and on current practice, and by asserting the need to confront the urgent realities of the present. Above all, these realities were new materials and new patterns of life: 'We must invent and rebuild the Futurist city like an immense and tumultuous shipyard, agile, mobile and dynamic in every detail; and the Futurist house must be like a gigantic machine.' Anticipating Le Corbusier's concept of the house as a 'machine for living in', Sant'Elia describes, in effect, a fantastic redevelopment of an American city such as New York, where decoration is abolished, skyscrapers dominate and life is recognised as a dizzying synthesis of vertical and horizontal forces: 'the street will no longer lie like a doormat at ground level, but will plunge many storeys down into the earth, embracing the

metropolitan traffic, and will be linked up for necessary interconnections by metal gangways and swift-moving pavements.' It was part of the Futurist faith that Italy should look towards America for inspiration rather than to Europe. At an ideological level, however, the Futurist city, dubbed 'Milano 2,000' by Sant'Elia, was at odds with American individualism, for it sought to control and to harmonise human life in a quasi-totalitarian structure. Whatever Sant'Elia's rhetoric about new freedoms and the expression of the spirit, his vision anticipates the authoritarian fantasies of Mussolini's Fascist mass society. Sant'Elia's drawings, perhaps ominously, rarely include human figures

38
Mario Chiattone

Construction for a Modern Metropolis
1914

Ink on paper
106 × 95
(41¾ × 37½)
Dipartimento di Storia delle Arti dell'Università, Gabinetto Disegni e Stampe, Pisa

and show a mechanised world disconnected from nature. Transport systems, living quarters and industrial areas are brought together in a complex series of relations in which people are effectively productive and communicative units in a monumental circulation of forces. In a sense, the human being has been fully absorbed into the dynamic field of Futurist painting. This sci-fi unreality is accentuated in Chiattone's drawings of the 'modern metropolis' (fig.38) where the quality of artificially lit stage scenery anticipates the spectacular scenography of Fascist ceremonial architecture.

FUTURISM ON THE ROAD

Marinetti, who called himself 'the caffeine of Europe', spread the word about Futurism across the continent through exhibitions, performances, events, pamphlets, publicity stunts and a shrewd manipulation of the press. By the outbreak of the First World War, Futurism was a household name throughout Europe and had even gained a foothold in the United States and in Brazil and Mexico. Synonymous with outrage, violence, novelty and excitement, it was by far the most visible face of an international avant-garde that was otherwise largely unknown to, and certainly little understood by, the great mass of people. It is not possible in a study of this length to examine the extraordinary extent of the international impact of Futurism; rather we will look briefly and highly selectively at that impact in two contrasting contexts – Britain and Russia.

'THE GREAT VORTEX': FUTURISM AND VORTICISM IN LONDON

The response to Futurism among young artists in London eventually led to the formation of the Vorticist movement which, while heavily indebted to many aspects of the Italian group's ideas and practices, was also fiercely and critically independent. English audiences had been introduced to post-Impressionist painting through two exhibitions organised in 1910 and 1912 in London by the critic and painter Roger Fry. By Futurist or Cubist standards, Fry's exhibitions were tame and uncontroversial but had nevertheless fascinated and alarmed many through their display of works by Paul Cézanne, Paul Gauguin, Henri

Matisse and others. When the same British audience was confronted in 1912 by the first Futurist Exhibition at the Sackville Gallery in the West End, it was still more astonished, even horrified, by what it saw as the excesses of the new tendencies in European art. With the various turbulent Futurist events organised to publicise the Italians' presence in London, and the political issues of Ulster, the suffragettes and syndicalist-inspired strikes in the major industries, a fairly conservative public may well have felt that they had good reason to be concerned about the provocatively novel and seemingly deliberately ugly and discordant art of the Futurists. Many would have been unimpressed by Marinetti's preparatory speech delivered at the Lyceum Club in 1910 in which he chided them for 'the dismal, ridiculous condemnation of Oscar Wilde. Intellectual Europe will never forgive you for it.'

Marinetti made strenuous efforts to recruit support among the avant-garde in London but had only very limited success. He was certainly an important catalyst in 1912 and 1913 in generating debate and experiment among artists and writers but his sole committed supporter in London, the painter Christopher Nevinson, who had studied at the Slade School of Art and in Paris, was ostracised by his peers when he signed the 'Vital English Art: Futurist Manifesto' in 1914 at Marinetti's instigation. Nevinson had met Severini at the Sackville exhibition and had travelled with him to Paris where he was introduced to Boccioni, Apollinaire and others. The impact of his introduction to Futurism and the scene in Paris was immediate and dramatic. His work, already often concerned with contemporary urban scenes and modern life in general, focused in paintings such as *The Arrival* (fig.39) on movement, fragmented form and the romance of travel.

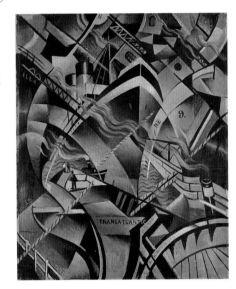

39
Christopher Richard Wynne Nevinson
*The Arrival c.*1913
Oil on canvas
76.2 × 63.5 (30 × 25)
Tate Gallery

40
Wyndham Lewis
Print from portfolio
Timon of Athens 1912
Tate Gallery Library

In Wyndham Lewis (1882–1957), painter, writer and the leading figure of the Vorticist movement, Marinetti came up against a rival of remarkable talent and intellect. Lewis had trained at the Slade School of Art at the turn of the century and travelled extensively in Europe from Brittany to Munich, Paris to Madrid. By the time he resettled in London in 1909 he had acquainted himself with the main intellectual and artistic currents in France and Germany and had developed his own aesthetic philosophy. Influenced by writers such as the anarchist Max Stirner and by Nietzsche, he was also familiar with Cubist and Expressionist art.

There is little doubt that Lewis was highly receptive to Futurist ideas and art, and works such as his illustrations of 1912 to Shakespeare's *Timon of Athens*

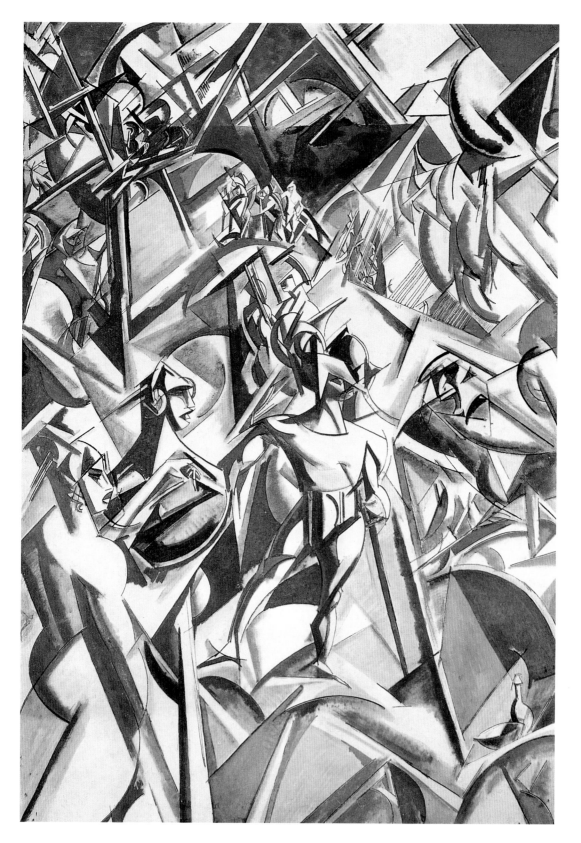

(fig.40) show a marked affinity with Boccioni's output during this period. However, Lewis's art is more severely geometrical and lacks the loosely turbulent psychological atmosphere evoked by Boccioni, whose aim was to convey a sense of real movement. Lewis rejected the Futurist obsession with what he saw as the trappings of modernity and the romance of speed, and in his work placed the emphasis instead on surface and form.

By 1914 Lewis had gathered around himself a loosely allied group of like-minded artists and, along with the American poet Ezra Pound (1885–1972) and a wealthy supporter Kate Lechmere, founded the Rebel Art Centre, a group defined partly by rivalry with the Bloomsbury artists of the Omega Workshops such as Vanessa Bell, Duncan Grant and Roger Fry. The Rebel Art Centre did not survive long but was the crucible in which Vorticism was created. The image of the vortex was intended to convey a sense of dynamism but one at odds with what the English artists saw as, in Pound's phrase, the 'accelerated impressionism' of Futurism. The vortex has a still centre around which form is organised, and by this Lewis and his associates meant partly to suggest that Futurism was undisciplined and superficial. Lewis and Pound, in particular, were keen students of Chinese and Japanese art and saw analogies between their work and oriental painting and aesthetic theory. Deeply committed to an engagement with the spirit of contemporary life, they nevertheless stressed the need for detachment and were unimpressed with the heroic immersion in matter and movement that was so central to Futurist thinking. Although both men were also interested in the anarchist and radical politics espoused by the Italians, they made it a requirement that the artist remain aloof from the sphere of action and insisted on the autonomy of art.

The journal *Blast*, which first appeared in July 1914 was the Vorticists' attempt to take on the tactics of the classic Futurist manifesto and to develop Marinetti's typographical experiments (fig.42). Where the Futurists used their varied typefaces in a spirit of wayward polemic, often effacing the difference between text and image, the *Blast* manifestos are almost architectural in their organisation and perhaps emulate the style of the popular newspaper or billboard. While there is a strong nationalistic tone at work in *Blast*, particularly through contrasts with French and Italian culture, there is, equally, a satirical attack on British assumptions, snobbery and complacency. In the same spirit that Marinetti had attacked Italian 'passéism', so the pages of *Blast* contain a series of attacks on the English climate, aestheticism, humour, sport, and Victorian middle-class values. On the other hand, England is 'blessed' for its maritime and industrial power and for its tradition of satire. This dialectical approach knowingly creates a gap in which the Vorticist vision is intended to emerge: 'We start from opposite statements of a chosen world. Set up violent structure of adolescent clearness between two extremes.'

41
Wyndham Lewis

Vortex symbol, reproduced in *Blast: Review of the Great English Vortex*, no.1, 1914, edited by Wyndham Lewis

42
Page from *Blast: Review of the Great English Vortex*, no.1, 1914

The polemical attacks by the Vorticists on Futurism (or as they dubbed it, 'automobilism') drew on their belief that the Bergsonian emphasis on life and the flux of time was at odds with art's focused presence. Pound wrote: 'Futurism is the disgorging spray of a vortex with no drive behind it, DISPERSAL.'

The vortex symbol that appears in *Blast* (fig.41) suggests an elaborate reference to the ideological position of the English artists and carries strong nationalist and racial overtones. It has been persuasively argued that the curious inverted lampshade-like form is based on a nautical storm-cone. These canvas objects were used on ships to indicate the direction of storms, controlled by a rope that made them point either up or down. A storm-cone pointing up warned of a storm coming from the north. Thus the suggestion of this secret emblem is that Vorticism is a northern European cultural storm directed against the Mediterranean gales of Futurism. 'Let us once more wear the ermine of the north', exclaims the opening manifesto. Lewis frequently pointed out that England was the home of the industrial revolution and that she had no need of the sentimental 'hysterics' of excitable 'Latin-types' for whom economic upheaval was a far more recent experience. England, 'Industrial island machine', proud of its seafarers and ports with 'heavy insect dredgers', was the home of Jonathan Swift with his 'solemn bleak wisdom of laughter' and of 'the British Grin'.

Lewis's particular notion of human life was based on the idea of dualism, or the radical divorce of mind and body. For him the mind, no matter what science might say and the Futurists urge, was at war with the body. This belief meant that he held to an utterly sceptical view of the political action that provided the main impulse for Futurism. Where Marinetti, Boccioni and their colleagues enthused about the loss of self in the crowd and the identification with matter in a sort of ecstasy of communication with the life-force, Lewis cautioned in favour of individual, indeed deliberately ego-centred, self-reliance, eyes fixed on the present rather than the future.

While few of Lewis's major Vorticist canvases survive, many works on paper still exist. These show that by 1914 he, like his fellow Vorticists, was engaged with abstraction. There are, however, few entirely non-representational works. His monumental canvas *The Crowd* of 1914–15 (fig.44) shows how he worked

between a highly formalised approach and the demands of representation without which, he believed, art could have no powerful significance. The painting is also a critique of Futurist art and political ideology. In the bottom left-hand corner a number of large robotic figures, gathered near a French national flag, appear to be opening or closing a door separating them from a cityscape, which dominates the picture. Between the interstices of this schematic representation of city buildings, and across wide open spaces, move beehive-like configurations of figures, suggestive of mobile political groups – one of the protagonists holds a prominent red flag. The regimented phalanxes appear to be moving towards the top right hand corner of the painting where more compact groups of figures are perhaps at work in a factory, suggested by curved shapes.

Whether or not *The Crowd* refers to an actual event in French political history, recent or otherwise, has not been established. It is likely that it was painted after the outbreak of the First World War in August 1914: 'The Crowd Master', a story by Lewis in the second issue of *Blast*, which appeared in June 1915, gives an account of the masses in London gathering in the immediate lead-up to the declaration of war. Lewis equates the crowd with war and death and the individual with peace: 'The Crowd is an immense anaesthetic towards death.' Such sentiments, as we shall see, could hardly be further from the attitude of the Futurists who violently encouraged Italy's entry into the war on the allied side in 1915. It is extremely likely that Lewis, who was moving towards a rather maverick conservatism during this period, was also influenced in his choice of subject matter by the writing of the right-wing French sociologist Gustave Le Bon. Le Bon's book *The Psychology of Crowds*, published in 1895 and translated into English the following year (though Lewis read French fluently), analysed the psychology of crowd behaviour and was highly influential on thinkers from Freud to Hitler at the beginning of the century. Le Bon, an anti-democrat, saw humans as psychologically weak and easily manipulated through education, political propaganda and other means. Most individuals, claimed Le Bon, easily surrendered their independence to the will of organised elites and happily merged their interests with those of the multitude. With this merging of the self, obviously, came loss of responsibility. Le Bon's argument is a complex one but clearly made many telling points about human psychology and modern mass societies. *The Crowd* similarly presents social and political life as an ominous and alien sphere from which the artist, at least, needed to remain detached. It represents, so to speak, the politics of

43
Edward Wadsworth

*The Port c.*1915

Woodcut on paper
18.7 × 12.7
(7¼ × 5)
Tate Gallery

44
Wyndham Lewis

The Crowd 1914–15

Oil on canvas
200.7 × 153.7
(79 × 60½)
Tate Gallery

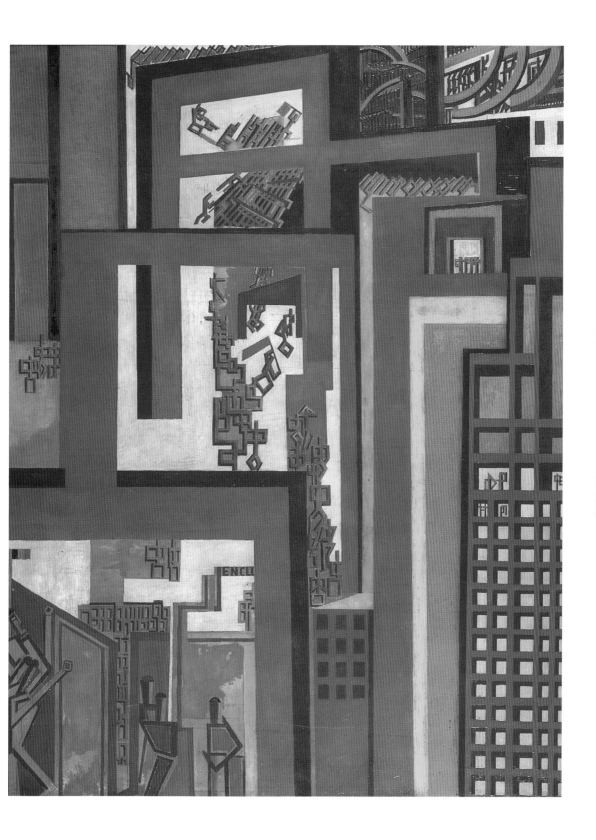

disengagement, where Russolo's *Revolt*, for example, had urged engagement.

Although the Vorticists were a less unified group and were certainly less politically grounded than the Futurists, there was among their varied work a broadly shared aesthetic. Edward Wadsworth, who came from a wealthy, northern, industrial family and who had trained first as an engineer and then, in Munich and London as a painter, was close to Lewis (the two, for instance, went on walking holidays in Yorkshire). His series of woodcuts of industrial

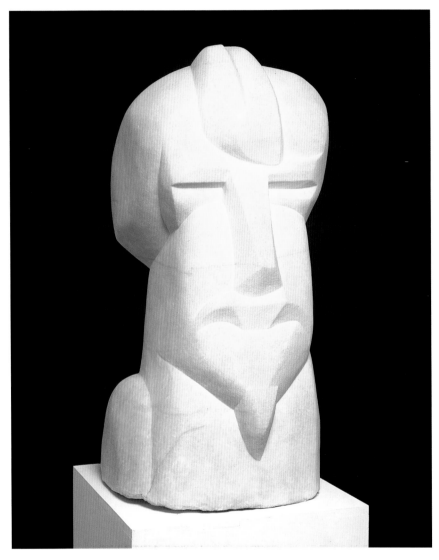

England displayed extraordinary delicacy and compactness of form. Vorticism demanded a geometrical and condensed translation of the perceived world and Wadsworth's work of this period was among the most original and successful. Lewis noted this quality in one of Wadsworth's port scenes, praising 'its white excitement, and compression of clean metallic shapes in the well of the harbour, as though in a broken cannon-mouth' (fig.43).

Vorticism had grown partly from its literary counterpart, Imagism. Two

leading figures of Imagism, Ezra Pound and the philosopher, critic and poet T.E. Hulme, were closely involved in the contemporary debates in London about art and poetry, and were instrumental in the formation of the new aesthetic.

Pound, as has been mentioned, was deeply influenced by oriental poetry and had made a particular study of the Chinese ideogram. He formed a close relationship with the young French sculptor Henri Gaudier-Brzeska who had moved to London in 1908 and whose ink drawings show the influence of oriental calligraphy, no doubt reflecting the interests of his American friend. Gaudier's marble *Hieratic Head of Ezra Pound* (fig.45), carved in his studio under a railway arch at Putney Bridge in 1914, indicates the mix of primitivism, shamanism and modernist geometry typical of his work at this time. In profile the sculpture is unmistakably a phallus, presenting Pound as a source of creative power and poets in general as 'antennae of the race', as the American believed. The sharp, geometrical planes and compacted forms of the sculpture share with Futurist art a certain modernity, which is then contradicted by strong archaic resonances.

45
Henri Gaudier-Brzeska

Hieratic Head of Ezra Pound 1914

Marble
91.4 × 48 × 42
(36 × 19 × 16½)
Courtesy Anthony
d'Offay Gallery, London

46
Jacob Epstein

Doves 1914–15

Greek marble
64.8 × 78.7 × 34.3
(25½ × 31 × 13½)
Tate Gallery

The same quality of streamlined primeval forces is evident in the sculpture of the American, Jacob Epstein, who had settled in London in 1905. His carving *Doves* (fig.46) compresses an act of copulation into a compact shape highly suggestive of some streamlined mechanical form – a strange variation on the theme of sex-machine! Epstein's work was particularly admired by T.E. Hulme, who had translated Bergson into English, as well as the writings of the French syndicalist Georges Sorel. In seeking to explain the importance of Epstein's sculpture Hulme drew on the writings of the German philosopher of art Wilhelm Worringer. Worringer argued that there were two kinds of art – the abstract and the naturalistic. While the latter, typified by Greek and Renaissance art, depended upon a humanist sensibility and empathy with the body, the abstract, as found in Egyptian and Oceanic art for instance, was rooted in a deep fear of nature. The flowing forms of naturalistic art were denied by the harsh geometry of abstract art as the latter sought to impose order on the arbitrary and temporal life of the natural world. Hulme, citing artists such as Epstein as evidence, proposed that European art was entering a new phase of abstraction and that a concomitant social order based on hierarchy and tradition was imminent. Thus, while the Italian Futurists saw in the machine age auguries of almost wild human emancipation through technology, Hulme, and a number of the Vorticists, saw machinery and the art of the engineer's drawing as the signs of an extraordinary authoritarian modernism emerging in the culture of their time.

BEYOND REASON: FUTURISM IN RUSSIA

We have seen that Futurism, a term that for many during the second decade of the century was virtually synonymous with 'avant-garde', and therefore often imprecisely used, was both an international and a nationalist phenomenon. It was international in the way that avant-garde culture inevitably was in this period on account of the promiscuous mobility of the ideas of its protagonists; it was nationalist, as is clear in the case of Italy's relationship with

Britain, and in the drive to find an 'authentic' culture of new or revived nationhood. The cultural geography of Futurism in the wider context of the avant-garde, then, is a highly significant factor in our understanding of its role in European history prior to the outbreak of the First World War.

In the case of Russian 'Futurism', a label that should be viewed with some caution, these questions of cultural interchange are especially important because they also involve a broader issue about 'east' and 'west', the 'oriental'

and 'occidental'. One way in which Russian Futurists and other avant-gardists in the two main artistic centres, Moscow and St Petersburg, saw their engagement with modernism and modernity was in a pronounced commitment to the idea of Russia and its language. This meant that a simple response to, or imitation of, the precepts and forms of Italian Futurism was impossible.

Although Marinetti claimed to have travelled to Russia before his well-documented visit of January 1914, it was this trip that had the greatest impact. Invited to visit the country, Marinetti saw, perhaps more clearly than was warranted, an opportunity to establish an important outpost of his movement. Italian Futurism had been familiar to Russian artists and writers since 1909 through translations of manifestos and critical attention in newspapers and journals. Predictably, Marinetti arrived in Moscow in a storm of publicity and proceeded to insult, at a series of public events, the Kremlin, Tolstoy and Russian art. Although most of his Russian audiences responded with warmth

47
Mikhail Larionov
Soldier on a Horse
*c.*1911
Oil on canvas
87 × 99.1 (34¼ × 39)
Tate Gallery

48
Kasimir Malevich
Front cover of *The Three*
by Velimir Khlebnikov,
Alexei Kruchenykh and
Elena Guro 1913
Lithograph 16.7 × 15.8
(6½ × 6¼)
British Library

and enthusiasm to this assault, a number of artists, such as the painter Mikhail Larionov (1881–1964), who recommended that Marinetti should be greeted with rotten eggs, expressed intense hostility to the bombastic foreigner. Something of the tone of this nationalist resistance is conveyed in a leaflet written by the writers Velimir Khlebnikov and Benedikt Livshits and distributed before one of Marinetti's lectures in St Petersburg: 'Today some natives and the Italian colony on the Neva's banks ... prostrate themselves before Marinetti, thus betraying Russian art's first steps on the road to freedom and honour, and placing the noble neck of Asia under the yoke of Europe.' Although the writers David Burliuk and Vasily Kamensky claimed that Futurism was metropolitan and cosmopolitan, there was a pronounced tendency for Russian artists to reject this image.

Disentangling the various art-political agendas of the warring groups and individuals is a frustrating activity and often no more fruitful than trying to decide who innovated first in the matter of technique or how one artist may or may not have 'influenced' another. However, this matrix of claim and counter-claim is the very stuff of the modernist art milieu of the period, particularly in the confusing and volatile Russian scene. While there can be little doubting the importance of Italian Futurism for artists in Russia, it is also true that Marinetti had a scant understanding of the complex and often highly innovative nature of Russian avant-garde art. He also would have found it difficult to comprehend the particular circumstances of Russian society and culture at the time – a period bracketed by the revolutions of 1905 and 1917.

A clear characteristic of Russian modernism after Symbolism and Impressionism was its emphasis upon the 'primitive' and the irrational. By 'primitive' is meant a reverence for a range of sources from crude *lubok* (peasant woodcuts), orthodox religious icons, children's art and shop-signs, to gingerbread figures, graffiti and prehistoric art. The paintings of Mikhail Larionov (fig.47) and Natalia Goncharova (1881–1962) show such sources in abundance. In the main, indeed, this was an art of peasant and rural life rather than of the proletarian and urban world with which the Italians were almost exclusively concerned. Even though technically such artists showed a sophisticated awareness of contemporary French, German and other European art, they reflected a nation at a different stage of industrial and social development and a set of cultural factors often alien to those of neighbouring countries to the west. Thus Russian Futurism carried a notion of the modern, the new and, indeed, the future, distinct from that of Marinetti and his colleagues. Like the Vorticists, many Russian artists saw the Italians as overly publicity minded and inclined to view modernity simply in terms of the obvious features of technological change. Khlebnikov coined the term *budetlyan* – from the future of *byt* (to be) – meaning 'the artist is a man of the future'. This picks up on the existential sense of Futurism that we considered earlier and which was indeed an intrinsic sense for the Italians too. Yet there are few aeroplanes, cars, building sites and so on in Russian Futurism. Rather, there is a powerful commitment to a formal experimentation and disruption of visual and verbal syntax in the name of a national spiritual rebirth.

The close link between writers and artists in Russia is evident in the wave of collaborative small-edition poetry publications that were at the heart of the Futurist enterprise there (fig.48). The poetry is characterised by neologisms, illogicality, baby-talk, deliberate mistakes and misprints. Printed on wrapping paper and wallpaper, bound in sack-cloth and using other unconventional materials such as tin-foil, these enigmatic books have the quality of sculptural objects where words and images, calligraphy and illustration become interchangeable. Alexei Kruchenykh invented the word *zaum* (bringing together parts of words meaning 'beyond' and 'reason') to suggest a new zone of 'transitional' creativity in which what were taken to be conventional structures of mental process and the logic of language are broken down to provoke an awareness of realities beyond what Nietzsche had called 'the prison-house of language'. There is also a complex philosophical background to these aesthetic practices in contemporary linguistics and literary scholarship in Russia. The philologists Alexander Potebnya and Alexander Veselovsky, and, later, Formalist philosophers such as Roman Jakobson and Boris Eichenbaum, stressed the formal and autonomous qualities of poetry and, perhaps most importantly, its potential 'distancing' and defamiliarising effects. The attraction of writers such as Vladimir Mayakovsky to these ideas led to close contact between the Futurists and groups such as 'Opojaz' (Society for the Investigation of Poetic Language) in St Petersburg. One of the fascinating consequences of this marriage of academic and artistic interests was that the two found common political cause in the period after the Bolshevik revolution when, prior to Stalinist intervention, they helped to create an intellectual and creative climate

49
Natalia Goncharova

Rayonnist Composition
*c.*1912–13

Pastel on paper
31.8 × 21.6 (12½ × 8½)
Tate Gallery

that deeply affected the new state's cultural policy. Like Marinetti, however, they soon learned the cost of affiliation with political power.

The Russian artist perhaps most associated with Futurism and its subsequent developments was Kasimir Malevich (1878–1935). Following the 'Rayonnism' (strictly translated 'Rayism') of Larionov and Goncharova in 1912 and 1913 (fig.49), which, clearly influenced by Boccioni and other Futurists, was concerned with 'spatial forms which are obtained through the crossing of reflected rays from different objects' and with eliminating 'the boundaries that

exist between the surface of the painting and nature', Malevich invented the title 'Cubo-Futurism' to define a new phase in the rapidly developing saga of Russian modernism. His paintings in 1911 and 1912 had shown an extraordinary combination of primitivism, Léger-like tubular forms and a Futurist concern with the depiction of movement. In 1913 and 1914, however, Malevich, who was also working on literary and theatrical collaborations with Mayakovsky and others, radically changed gear. Dubbing his new method – partly inspired by Cubist collage – 'alogist', he introduced surreal combinations of words and images into works such as *An Englishman in Moscow* of 1914 (fig.50), which are exactly in tune with the procedures of his literary peers. Again, the 'modernity' of such work is driven by its irrationality of technique rather than by a requirement to reflect the obvious features of modern city life.

By 1915 Malevich's art, which he now called Suprematism, had become entirely 'non-objective'.

One of the fascinating features of works such as *Dynamic Suprematism* (fig.51) is that their resolutely abstract appearance did not entail a matching loss of subject matter. Malevich claimed that his celebrated *Black Square* of 1913, originally hung across the corner of a room above a door to emulate the positioning of traditional icons, was a 'zero-point' from which an entire new realm of visual form would grow. Thus in his theoretical writings, every bit as ambitious as those of the Italian Futurists, he claimed a sort of Hegelian historical necessity of development from the earthbound realism of the mid-nineteenth century through an increasing analysis of form in the art of

Cézanne and the Cubists to an aerial and, finally, a cosmic world freed from the gravity of Suprematism. Much influenced by the ideas of contemporary occult writers such as P.D. Ouspensky about the fourth dimension , Malevich, as it were, rewrote art history to put himself in the vanguard not just of a new art but of a new consciousness and, indeed, a new universe. Extreme as his claims may seem, his tactics were not unique!

In Britain and Russia, therefore, there were important and vigorous responses to Italian Futurism. The artists of these countries were not in thrall to Marinetti's group – although they often underplayed its significance and originality – but their responses to it revealed its fertile and suggestive

50
Kasimir Malevich

An Englishman in Moscow 1914

Oil on canvas 88 × 57 (34½ × 22½)
Stedelijk Museum, Amsterdam

51
Kasimir Malevich

Dynamic Suprematism 1915 or 1916

Oil on canvas
80.3 × 80 (31½ × 31½)
Tate Gallery

expansiveness. The same can be said of artists in many other countries at this time including Germany, France, Poland, Hungary and the United States. Italian Futurism, for all its aesthetic and political flaws, its pretentious claims and glory-snatching, was a truly seminal force that crossed national and artistic boundaries with mischievous and arrogant ease.

6

52
Gino Severini

The Hospital Train
1915

Oil on canvas
117 × 90 (46 × 35½)
Stedelijk Museum,
Amsterdam

'WAR: SOLE HYGIENE OF THE WORLD'

Futurism celebrated war. When it finally came to Europe in August 1914
Marinetti and his followers, unsurprisingly, urged Italians to join the allied side
against the Germans and Austro-Hungarians with whom Italy at the time had a
triple alliance. Futurist manifestos and closely, if uneasily, aligned journals such
as *Lacerba* described the choice facing the nation as a cultural one where
Giolliti's neutrality was not an option and heroic sacrifice was a duty. War was
seen as a final glorious synthesis of all the forces pushing Italy towards
'Panitalianism' and modernisation. Violent demonstrations were staged in
various Italian cities, Balla designed 'anti-neutral' clothing, Austrian flags were
burned, fights with pacifists led to riots and, for extremists such as Boccioni,
nights were spent in jail. Leaflets were distributed, such as the 'Futurist
Synthesis of War' of September 1914 with Carrà's conceptual diagram setting
the forces of progress, including Italy, England and France, against the
passatismo (past-mindedness) of the hated Austrians and Germans. At the heart
of this Bergsonian battle between life and invention, on the one hand, and
rigidity and analysis, on the other, was the power of *Futurismo*, the embodiment,
simultaneously, of the will-to-power, anarchist internationalism and historical
nationalism.

During this period the interventionist Futurist 'Political Action Theatre' was
created. That it was a cause of only mild concern for the authorities, however, is
shown by this extract from a document sent by the Prefect of Milan to the
Public Security Office in Rome following an 'event' at the Teatro del Verme
during the premiere of Puccini's opera *Fanciulla dello West* on 15 September 1914:

'After the first act of the opera, the well-known Marinetti unrolled from the upper circle an Italian flag and shouted "Long Live Italy and France". At the same time, from another gallery, the Futurist Carrà waved what looked not like a flag, but some formless cloth of tiny dimension, tinted in two colours, yellow and black, which he then tore into pieces. The large audience was busy applauding the artists and Maestro Puccini, who were just taking their curtain call, and were nearly oblivious to the action ... The whole thing was a totally isolated case and was carried out by individuals, who did not find the slightest following in the audience.' Marinetti seems to have had greater success inflaming the patriotic passions of young students by interrupting lectures at universities, and of the working classes when he demonstrated support for France alongside the socialist leader Benito Mussolini in 1915. Believing that he had persuaded the previously pacifist Mussolini to side with the 'interventionist' cause, he claimed him also as a convert to Futurism. Art, he convinced himself, had merged with political action.

Finally, Italy entered the war in May 1915 and many of the Futurists were quick to volunteer for active service. Marinetti, along with his Milanese supporters, Boccioni, Russolo, Sant'Elia, Ugo Piatti and Mario Sironi joined the short-lived Lombard volunteer Cyclist Battalion in July 1915 and saw action in the vicious fighting in the Trentino. In spite of the military commitments of the movement, Marinetti kept Futurism alive during the war through 'action theatre' supporting the war effort, and by encouraging his artists to respond to the 'splendour of the conflagration'. He had written to Severini in Paris in November 1914: 'Try to live the war pictorially, studying it in all its marvellous mechanical forms (military trains, fortifications, wounded men, ambulances, hospitals, parades, etc.).' Severini took Marinetti's advice and, although he was hardly a belligerent enthusiast for war, he produced a series of images of armoured and hospital trains (fig.52) moving through Paris, through which he aimed to create what he termed 'Symbols of War': 'A few objects, or a few forms that related to a certain reality, perceived in their "essential state" as "pure notion", provided me with a highly condensed and extremely modern idea-image of war.' These paintings were shown at an exhibition of Futurist war

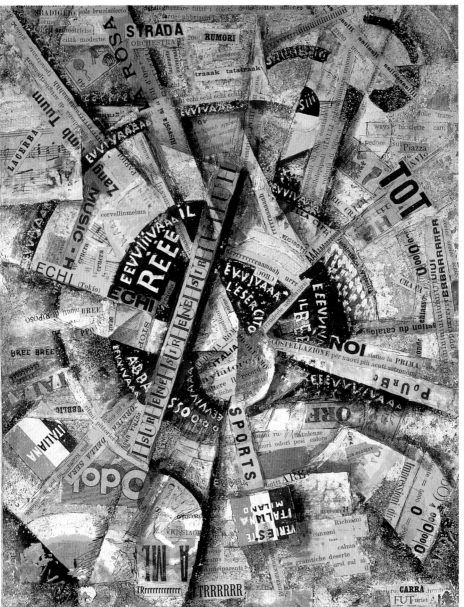

53
Carlo Carrà

*Interventionist
Manifesto* 1914

Collage on paste-board
38 × 30
(15 × 11¾)
Collection Mattioli,
Milan

54
Carlo Carrà

*The Drunken
Gentleman* 1916

Oil on canvas
60 × 45
(23¾ × 17¾)
Private Collection

art in Paris in 1916 and the lecture that Severini gave during the display formed the basis of two articles in the *Mercure de France*. The significance of these articles is that they demonstrated a profound shift in Severini's aesthetic thinking, which matches similar fundamental changes of outlook in Boccioni and Carrà. In effect, Severini was moving towards a rationalist reworking of tradition and figuration and away from the disrupted and dynamic forms of Futurism in its heroic years. In this he can be seen as part of the 'return to order', which many European artists, as varied as Picasso, Wyndham Lewis and Carrà, were undergoing during and after the war.

Carrà had been moving away from 'Marinettism', as it was dubbed by detractors, and had spent much time in Paris during 1914. His correspondence with Severini shows that both artists were contemptuous of what Carrà called 'the dung-heap of social humanitarian sentimentality'. The wonderful exuberance of Carrà's 'interventionist' work, made upon his return to Italy at the end of 1914, however, shows that temporarily he was caught up in the patriotic fervour of the time and was subject to the 'sentimentality' he professed to despise: 'For me love of the fatherland was a moral entity and could not be considered as an abstraction but as a spiritual force.' His *Interventionist Manifesto* (fig.53) is a frenetic collage that uses a spiral composition to draw the spectator into a maelstrom of words, letters, colours and fragmented form suggestive of a propeller shredding newspapers. Following his earlier idea of painting noises, Carrà's 'plastic abstraction of civil tumult', as he describedthis piece, celebrates Italy, its aviators, the noises of war, Marinetti and other heroes of the modern movement. This kind of aestheticised propaganda was to have a deep influence on Dada artists such as Kurt Schwitters a few years later.

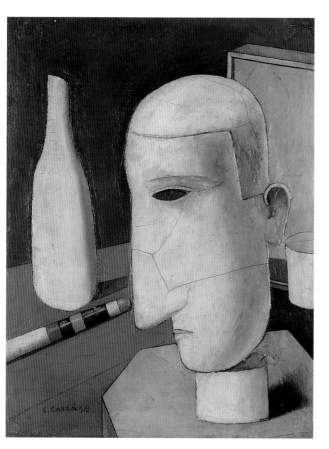

Such works, though, were a lively interruption to a general trend in Carrà's art satisfying what he called 'a need that had matured in me for something different and more measured … a strong desire to identify my painting with history, and particularly with Italian art history'. Like Severini, he was drawn towards his own artistic heritage – Giotto, Uccello and other early Renaissance Italian artists, whose work he interpreted as a peculiarly Italian expression of a

sense of gravity, solidarity and mystery. As with Futurism, Carrà's new art stemmed from a powerful sense of national identity, but it is as if having been part of a race towards modernisation he was now drawn to deeper aesthetic roots at odds with the excitability and fragmentation of Marinetti's vision. When he was called up to the infantry in 1917 Carrà was diagnosed mentally ill and eventually went to a military hospital in Ferrara where he met the Italian painter Giorgio de Chirico. De Chirico, who had no time for Futurism, had spent a number of years before the war in Paris where he had invented a way of painting that had anticipated Carrà's own interests and was to have a major impact on the development of Surrealism after the war. The two men coined the term 'Metaphysical Painting' to describe the work they produced during

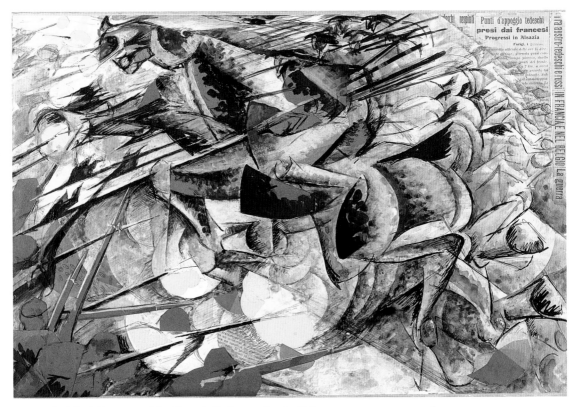

their brief partnership (fig.54). By 'metaphysical' they meant to suggest almost the opposite of what Futurism stood for: instead of movement, stillness; instead of fragmentation, structure; instead of interaction, separation. Whereas Futurism had stressed an immersion of the self in the dynamic flow of life and pushed art to polemical extremes, Carrà and de Chirico sought detachment, mental poise and simplicity. In some ways the two movements were dialectical partners within the complex changes in Italian culture that we have been examining. The tension between dynamism and classical order was to be a key theme throughout the Fascist era in Italy.

Boccioni, perhaps Marinetti's most loyal supporter, was killed in August 1916 when he was thrown off a horse while training with an artillery regiment near Verona. His diary records his excitement and fear during combat, in prose

worthy of Marinetti: 'Zuiii Zuiii Tan Tan. Bullets all around. Volunteers calm on the ground shoot Pan Pan. Crack shot Sergeant Massai on his feet shoots, first shrapnel explodes.' He also records his heroic attitude for posterity: 'Now the lieutenant comes and tells me to stay behind because my cough is dangerous for everybody at night in a surprise action . . . I protest with energy I would rather quit the corps than stay behind, "I'll cough with my head in a blanket but I want to be in the front line!"'

Curiously, little of his art is in tune with these experiences and the major war image of this period, *Lancer's Charge* (fig.55), was a collage made towards the end of 1914 before Italy entered the war. Over newspaper cuttings describing French advances against the Germans in Alsace, a row of mounted soldiers painted in

tempera attacks a group of German soldiers in a trench at the bottom left. The work is one of Boccioni's last clearly Futurist pieces and during 1915 and 1916 he began a reinterpretation of Cézanne which, although quite distinct from the direction taken by Severini or Carrà, showed a renewed concern with a more structured and sculptural approach. One of his last major paintings was a portrait of the Italian composer Ferruccio Busoni (fig.56) who had been one of the first buyers of his works. It was made in 1916 while the two men were staying at the villa of the marchese and marchesa in Pallanza in Lake Maggiore. A portrait commission may not give an accurate indication of Boccioni's true direction at this point but, along with other contemporary works, there is a marked concern with the legacy of Cézanne. Boccioni, however, did not aspire to an inert museum art and his late writings on art suggest a continuing commitment to chromatic luminosity and an underlying sense of dynamism within the material world.

7

DEDICATED FOLLOWERS OF FASCISM: SECOND FUTURISM, *AEROPITTURA* AND MUSSOLINI

By the end of 1916, with the death and departure from the movement of many of its key figures, the first period of Futurism was at an end. Marinetti, however, kept the movement alive by organising Futurist 'Synthetic Theatre' events, commissioning the film *Vita Futurista*, giving lectures, publishing, and looking for new recruits to the cause. Throughout, he was single-minded in his commitment to the war, a sentiment not shared by the majority of his fellow countrymen. By 1917, and after the humiliating defeat at Caporetto, most Italians were sick of the conflict and looked for scapegoats among the politicians, industrial magnates and military leaders whom they blamed for their devastated condition.

Newly formed combatants' organisations became a fertile breeding ground for Fascism exploited by Mussolini following his expulsion from the Socialist Party. There was much talk of the 'avant-garde of those who return from the front', who would instinctively know how to rejuvenate Italy at a time of national crisis. The solidarity of the servicemen was described as a *fascio combatto* (compact bundle), an image that became more potent and threatening to the government as the country collapsed into political and economic disorder at the end of the war. Mussolini deliberately called his new movement, launched in March 1919, *Fasci di Combattimento* in order to appeal to the four million ex-servicemen he believed would form the solid core of his support. In fact this bid was initially unsuccessful and Mussolini's first followers were the middle-class officers and administrators who felt they had lost the most following demobilisation; the *Arditi* (Daring Ones), or elite stormtroopers of the army,

who were attracted to violent political action; and the *Fasci Politici Futuristi*, who were, in effect, military followers of Marinetti and who formed the basis of the Futurist Political Party that had been launched in 1918. The latter's programme called for 'revolutionary nationalism', 'obligatory gymnastics, sport and military education in the open air', proportional representation, abolition of the monarchy, easy divorce, equal pay for women, 'socialisation of the land' and a host of other radical measures designed to sustain the Futurist pre-war vision in a time of dramatic upheaval and political opportunity. Marinetti was particularly keen to forge an alliance with the *Arditi*, whom he saw as the 'Men of the Future', as one leaflet put it: 'the Futurist at war, the bohemian avant-garde ready for everything, light-hearted, agile, unbridled; the gay power of a twenty-year old youth who throws a bomb while whistling a song from a variety show.'

For the next few years Marinetti pursued an idiosyncratic path through the complex web of Italian politics that formed the prelude to Mussolini's 'March on Rome' in 1922. While sympathetic to many aspects of extreme left-wing thought, he was ideologically opposed to the Marxist dogma of class struggle. It was Mussolini and Fascism, however, that Marinetti tracked most closely, and had done so since before the war. When the Fascist Party was formed in Milan in March 1919, Marinetti was elected to its Central Committee and in November was an unsuccessful candidate in parliamentary elections. Mussolini, who as early as 1914 had met Boccioni and expressed his great admiration for Futurism, sought the involvement of high-profile cultural figures such as Marinetti, the conductor Arturo Toscanini, and the poet and inspirer of Marinetti, Gabriele D'Annunzio who, famously, occupied the border town of Fiume for a year in 1919. Mussolini soon realised, however, that his big-name connections were not always helpful in attracting support and quickly began to distance himself from them. He could not afford to seem too involved with men such as Marinetti who, by 1920, was talking of a kind of anti-bourgeois and anti-papal revolution far too visionary and libertarian for Mussolini's pragmatic and authoritarian instincts.

Marinetti was equally suspicious of Mussolini whom he had described as early as January 1919 as 'a megalomaniac who will little by little become a reactionary'. Sadly for Marinetti, he needed Mussolini more than 'Il Duce' needed him. Marinetti and the Futurists contributed a great deal to Mussolini's efforts, through violence, agitation or propaganda, but they were to be disappointed by their eventual status within the Fascist state, which was indeed compromised and reactionary in a way utterly inimical to the Futurist ideal of 'elastic liberty'. When Marinetti resigned his position on the Central Committee in May 1920 after a theatrical exit from the second National Fascist Congress in Milan, his action ushered in a brief period of alignment with leftist politics, a return to the more artistic aspects of Futurism and an attempt to promote an 'Italian Revolution', more concerned with cultural freedom than its Russian counterpart. His hopes of working with Mussolini at the heart of the Fascist revolution were dashed, however, and from the middle of the 1920s, following Il Duce's proclamation of a Fascist dictatorship, Marinetti kept Futurism alive as a noisy and often brilliant and influential side-show to the

new regime's cult of the great leader presented through an elaborate bureaucracy and a spectacle of modernised classicism and nostalgia for the order and imperial splendour of the Roman Empire. Even Marinetti was unable to avoid institutionalisation, becoming a member of the new 'Reale Accademia d'Italia' in 1929, joining other co-opted figures such as the musician Ottorino Respighi, the dramatist Luigi Pirandello and the inventor Guglielmo Marconi.

Mussolini's cultural policy with regard to the visual arts, however, was surprisingly open and allowed for a variety of tendencies, including Futurism. The neo-classicism and espousal of *Valori Plastici* (plastic values) of the 'Novecento' movement favoured by Mussolini's influential Jewish mistress,

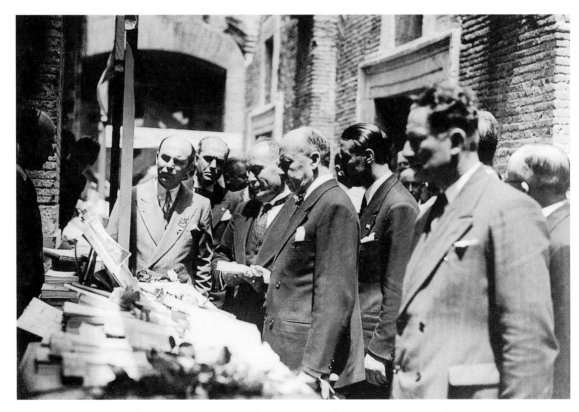

Margherita Sarfatti, was pre-eminent during much of the Fascist era in Italy and represented a far more 'modern' kind of pictorial traditionalism than that which was vigorously promoted for ideological purposes in Nazi Germany in the 1930s. Former Futurists such as Carrà, Mario Sironi and Achille Funi were typical of those avant-gardists sympathetic to Fascism who reinvented the notion of 'Italianità' through a continuing engagement with modernism. Mussolini's cultural eclecticism, particularly in painting, sculpture, design and architecture was the result of his attempt to hold a volatile national culture in check, as well as a testimony to his instinct that Fascism should maintain at least a strong sense of imaginative adventure and that it should be identified in the popular consciousness with an optimistic 'modern style'. In this fairly liberal climate there was certainly room for Marinetti to manoeuvre. The

Futurist Congress organised by Mino Somenzi in Milan in 1924, while plagued by factional unrest and even violence, was a public display through discussion and grand processions of the Futurists' willingness to enter into a dialogue with Fascism. It is interesting to speculate, however, to what extent Marinetti and his followers may have looked back with nostalgia on the days of Giolitti's government. While Fascism was seen by many as the final and triumphant phase of the 'Risorgimento', and the end of liberal corruption in Italy, some Futurists may have wondered just how far their new masters had produced the conditions for a fresh and more vigorous period in Italian art and culture. Certainly Marinetti's coming out in favour of the monarchy in 1924 and his confession of his Catholic faith would have seemed a bizarre sign of the times in which they were now living.

As has been noted, the First World War and its aftermath left Marinetti with a depleted core of Futurist visual artists. Balla became, by default, the leading figure and, based in Rome, built on the relationship he had developed since 1915 with the artists Fortunato Depero and Enrico Prampolini. The art of the 'Second Futurism' produced by Balla and Depero in the 1920s is characterised by a decorative abstraction that employs volumetric forms and was particularly suited to architectural design, fashion, typography and scenography (fig.58). Continuing the aims expressed in their 'Futurist Reconstruction of the Universe' manifesto of 1915, Balla and Depero attempted to create a popular style that could be applied to all areas of life and could form the basis of a 'total' Futurist environment.

57

Mussolini (holding book) with Marinetti (centre), Traianei market, Rome 1932

58
Giacomo Balla

Numbers in Love 1920

Oil on panel
77 × 56
(30¼ × 22)
Private Collection

In 1929 Balla, Depero and Prampolini, along with Marinetti and his wife Benedetta, were among the signatories of a 'Manifesto of Aeropainting'. While Balla abandoned his Futurist allegiances shortly after this, Prampolini became the leading exponent of *aeropittura*. Living mainly in Paris between 1925 and 1937, Prampolini had wide contacts with avant-garde movements across Europe, from the Purist and Abstraction-Création artists in France to De Stijl in Holland and Constructivism in Russia. *Aeropittura*, as Prampolini practised it, was a semi-abstract form of painting that sought to convey the 'cosmic' poetry of flight, and to visualise through biomorphic shapes and evocative colour the transcendence of the spirit towards higher states of consciousness (fig.59). These spiritual aspirations even made it possible for Prampolini and others to contribute to exhibitions of *arte sacra* (sacred art) organised by the new Fascist cultural syndicates and the Catholic church. In spite of clerical hostility to such work, Marinetti and the painter known as Fillia (a pseudonym for Luigi Colombo, 1904–1936) were able to claim in 1931 that 'only Futurist aeropainters

can make their canvases vibrate with impressions of the multi form and speedy life of angels in heaven and the apparition of saints'. While this may seem as surreal as some of Marinetti's recipes in his *Futurist Cookbook* of the following year ('Words-in-Freedom Sea Platter' and 'Simultaneous Ice-Cream' being two typical examples), it is also a salutary reminder that times change, ideas move in mysterious ways and even the most uncompromising radicals have to survive somehow.

Aeropittura picked up on a widespread contemporary fascination with aviators and all things aeronautical that can be seen in the films, novels and magazines of the period devoted to *aerovita*. As early as 1918 the Futurist Felice

59
Enrico Prampolini

Extraterrestrial Spirituality 1932

Oil on board
48 × 52 (19 × 20½)
Private Collection

60
Tullio Crali

Dogfight I 1936–8

Oil on board
100 × 110 (39½ × 43¼)
Private Collection

Azari had 'choreographed' aerial dances in a plane, supported by Russolo's music, in the skies over Milan. Most European countries had their pilot-heroes and Italo Balbo in Italy, who crossed the Atlantic in 1931, was the nation's leading aviator and symbol of the Fascist future. Many *aeropittori* such as Tato (1896–1974) and Alfredo Ambrosi (1901–1945) exploited this popular enthusiasm with images that were far more literal and militaristic than those of avant-gardists such as Prampolini and Fillia. One of the most successful exhibitors at the many *aeropittura* exhibitions across Italy during the 1930s was Tullio Crali (b.1910) who, in works such as *Dogfight I* (fig.60), created images glorifying the Italian airforce in a form of popular illustration that nevertheless drew on elements of modernism to achieve its almost cinematic effects.

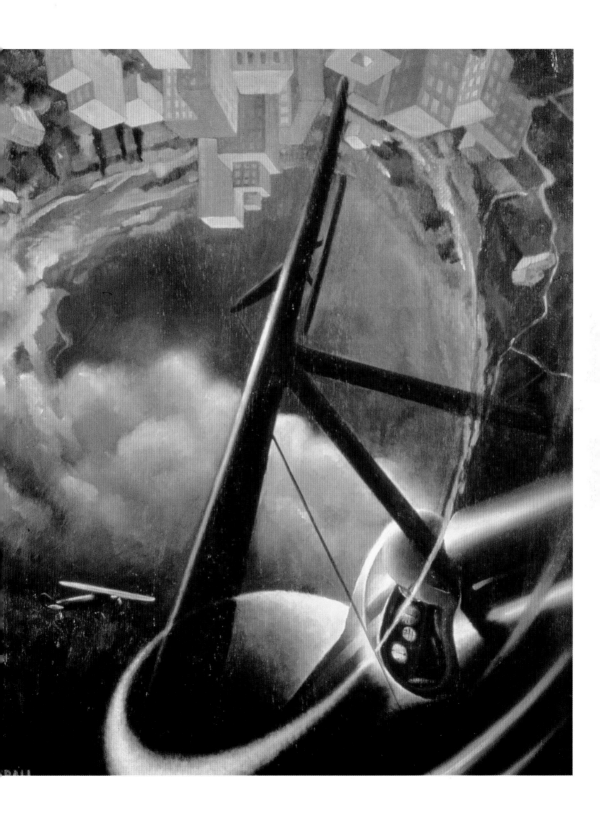

Marinetti fought long and hard to make Futurism an influential force across the whole spectrum of Italian culture between the wars. In many respects he was successful, particularly in the applied arts, even though the talent available to him was less impressive than that of his original cohorts. Regional movements from Turin to Sicily, not always loyal to Mussolini, kept the movement alive through exhibitions, events and publications and the Futurists led an admirable rearguard action against attempts by Fascist hardliners to introduce racist measures, based on Nazi policies, against 'degenerate art'. All this was achieved against a background of secret police surveillance of Marinetti and his colleagues and, as the political climate grew bleaker in the late 1930s, strenuous attempts to discredit the movement by its powerful enemies in the Ministry of Popular Culture. Marinetti himself, of course, was a committed Fascist, a patriot and a man of action; when Mussolini invaded Ethiopia in 1936 he did not hesitate to enlist as a volunteer at the age of sixty in the same spirit with which he had joined the army in 1915.

There was no avoiding the unpleasant truth for Marinetti, however, that by the end of the 1930s, despite the prevalence of Futurist cookery, fashion, ceramics, exhibition design and so on, Futurism had run out of steam. When war came in 1940, Marinetti became an unashamed apologist for the regime and Futurism degenerated into vulgar and inflammatory propaganda for the war effort, which often lapsed into the anti-semitism the movement had struggled against only a few years before. In 1940 Marinetti wrote of Mussolini thus: 'The duce radiant

61
Marinetti in Russia
1942

ouside his body solid elastic ready to strike ... continuously ... accelerating towards the light ... proud cosmic divinity of heroism and of invisible volcanoes but more than present applauded by his kinsmen with our throbbing hearts ... stupendous choice of revolutionary prototypes.' Whatever Mussolini may have made of these sentiments, they led Marinetti to follow his hero to the bitter end, firstly by fighting on the Russian front in 1942 (fig.61), and then, in 1943, by joining the Republic of Salò, set up by the Germans following Italy's military defeat that year. When he died alone in his bed in Bellagio on 2 December 1944, a few months before Mussolini's execution, Marinetti was unrepentant in his commitment to Fascism. Like many artists and intellectuals, including Ezra Pound, who had moved to Italy in the 1920s and become a fanatical admirer of Mussolini, Marinetti believed, in the face of overwhelming evidence to the contrary, that an authoritarian regime offered the best chance of realising his radical aesthetic and ethical vision.

BIBLIOGRAPHY

SOURCES OF QUOTATIONS

Apollonio, Umbro, ed., *Futurist Manifestos*, London and New York 1973:
BALLA: 'Futurist Manifesto of Men's Clothing' 1913, p.132
BOCCIONI ET AL: 'Manifesto of the Futurist Painters' 1910, p.25; 'Futurist Painting: Technical Manifesto' 1910, pp.27–31; 'The Exhibitiors to the Public' (*Exhibition of Works by the Italian Futurist Painters*, exh. cat. Sackville Gallery, London 1912), p.46
CARRÀ: 'The Painting of Sounds, Noises and Smells' 1913, p.114
MARINETTI: 'Founding Manifesto of Futurism' 1909, pp.20–1, 23; 'Destruction of Syntax–Imagination Without Strings–Words-in-Freedom' 1913, pp.95–106; 'The Futurist Cinema' 1916, pp.207–19
RUSSOLO: 'The Art of Noises' 1913, p.85
DE SAINT-POINT: 'Futurist Manifesto of Lust' 1913, p.71
SANT'ELIA: 'Manifesto of Futurist Architecture' 1914, pp.160–72.

Berghaus, Günter, *Futurism and Politics: Between Anarchist Rebellion and Fascist Reaction 1909–1944*, Providence and Oxford 1996:
AMENDOLA: 'Il convegno nazionalista', *La Voce*, vol.2, no.51, Dec. 1910, p.6
BOCCIONI ET AL: press release for Free Art Exhibition, Milan 1911, p.66
CARLI *Noi Arditi*, 1919, p.103
Document sent by Prefect of Milan 1914, p.75
MARINETTI: 'Poema dei Sansepolcristi' 1940, p.261
MARINETTI AND FILLIA: 'Manifesto of Futurist Sacred Art' 1931, p.245

Coen, Ester, *Umberto Boccioni*, exh. cat., Metropolitan Museum of Modern Art, New York 1988:
letter to Barbarantini, autumn 1910, pp.94–6, 121
letter to Severini, Nov. 1912, p.203

Flint, R.W., *Marinetti: Selected Writings*, London 1972:
'Let's Murder the Moonlight', 1909, p.51
'Against Passéist Venice' 1910, p.55
'Futurist Speech to the English', 1910, pp.59–65
'Techinical Manifesto of Futurist Literature' 1912, pp.84–5, 87, 89

Gray, Camilla, *The Russian Experiment in Art 1863–1922*, London 1986
LARIONOV: 'Rayonnist Manifesto' 1913, pp.136–41

Hartt, Frederick, *Florentine Art under Fire*, Princeton 1949, p.47

Kern, Stephen, *The Culture of Time and Space 1880–1918*, Cambridge, Mass, 1983, p.1

Markov, Vladimir, *Russian Futurism: A History*, London 1969:
KHLEBNIKOV/LIVSHITS: leaflet, p.151.

Nicholls, Peter, 'Futurism, Gender and Theories of Postmodernity', *Textual Practice*, vol.3, no.2, 1989, p.203

Tisdall, Caroline and Bozzolla, Angelo, *Futurism*, London 1977:
BOCCIONI: war diary, 19 Oct.1915, p.180
MARINETTI: *Zang Tumb Tumb* 1914, p.98
SEVERINI: *Autobiography*, p.191

FURTHER READING

In addition to the works cited above, for those wishing to pursue an interest in Futurism the following books provide some pointers into the vast range of material now available. Many of them carry extensive bibliographies.

Antliff, Mark, *Inventing Bergson: Cultural Politics and the Parisian Avant-Garde*, Princeton 1993

Art and Power: Europe under the Dictators 1930–45 (compiled by Dawn Ades, Tim Benton, David Elliott, Iain Boyd Whyte), exh. cat., Hayward Gallery, London 1995

Banham, Peter Rayner, *Theory and Design in the First Machine Age*, London and New York 1960

Berghaus, Günther, *Italian Futurist Theatre 1909–1944*, Oxford 1998

Blum, Cinzia Sartini, *The Other Modernism: F.T. Marinetti's Futurist Fiction of Power*, California 1996

Corbett, David Peters, *The Modernity of English Art*, Manchester 1997

Cork, Richard, *Vorticism and Abstract Art in the First Machine Age*, 2 vols., London 1976

Futurism in Flight: 'Aeropittura' Paintings and Sculptures of Man's Conquest of Space 1913–1945, (eds. Bruno Mantura, Patrizia Rosazza-Ferraris and Livia Velani), exh. cat, Accademia Italiana, London 1990

Futurismo and Futurismi (ed. Pontus Hulten), exh. cat., Palazzo Grassi, Venice 1986

Hewitt, Andrew, *Fascist Modernism: Aesthetics, Politics, and the Avant-Garde*, Stanford 1993

Italian Art in the 20th Century: Painting and Sculpture 1900–1988 (ed. Emily Braun), exh. cat., Royal Academy of Arts, London 1989

Kirby, Michael, *Futurist Performance*, New York 1971

Marinetti, F.T., *The Futurist Cookbook*, London 1989

Martin, Marianne, *Futurist Art and Theory 1909–15*, Oxford 1968

Perloff, Marjorie, *The Futurist Moment: Avant-Garde, Avant-Guerre and the Language of Rupture*, Chicago and London 1986

Pound's Artists: Ezra Pound and the Visual Arts in London, Paris and Italy, with essays by Richard Humphreys, John Alexander and Peter Robinson, London 1985

Sternhell, Zeev (with Mario Sznajder and Maia Asheri), *The Birth of Fascist Ideology: From Cultural Rebellion to Political Revolution* (trans. David Maisel), Princeton 1994

Taylor, Christina, *Futurism: Politics, Painting and Performance*, Ann Arbor 1979

White, John J., *Literary Futurism: Aspects of the First Avant-Garde*, Oxford 1990

Wohl, Robert, *A Passion for Wings: Aviation and the Western Imagination 1908–1918*, New Haven and London 1994

PHOTOGRAPHIC CREDITS

COPYRIGHT CREDITS

INDEX